HIDDEN
HISTORY
of the
UPPER
RIO GRANDE

Sandra Wagner &
Carol Ann Wetherill

Carol Ann Wetherill

THE
History
PRESS

Published by The History Press
Charleston, SC
www.historypress.net

Front cover: Zang's first hotel, established 1892. *The Denver Public Library–Western History Collection, X-7473.*
Back cover, top: *Last Stage to Del Norte*, by Ivan Curley; *bottom*: Charlie Mason, fish and boy at Hermit Lakes, circa 1910. *Author collection.*

First published 2017

Manufactured in the United States

ISBN 9781467137171

Library of Congress Control Number: 2016961712

This book is lovingly dedicated to Marie Ruth Wagner Baldwin, who left us too soon. Her message was to live life as if there may not be a tomorrow, and for her, there was not. Let that be a lesson for us all.

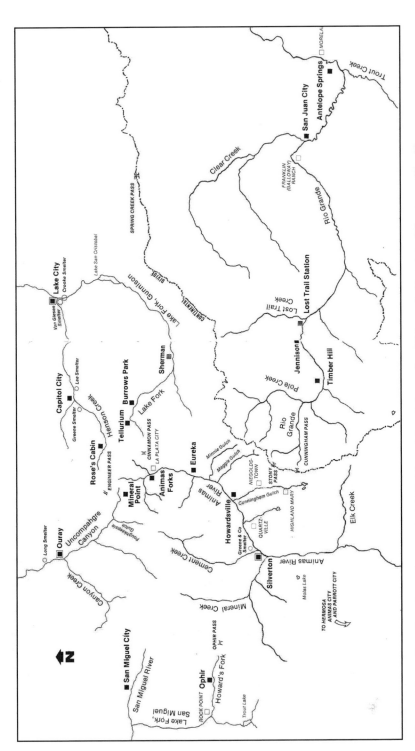

Historic Upper Rio Grande settlements in 1877. Many More Mountains, Volume 2: Ruts into Silverton. *Allen Nossaman.*

Contents

CONTENTS

Preface

The genesis of this series of short stories were newspaper articles about Upper Rio Grande and western San Luis Valley history that we have been writing for the past several years. Many hours of sifting through historic newspapers, carefully searching county archives, talking to local residents and reading many a history book made the stories come to life. The intent is to appeal to a broad audience. This book of southwestern Colorado history aims to be something one can pick up and read on vacation—something interesting and sometimes funny—and a treasure to take home to family and friends. Although painstakingly researched and documented, the stories are intended to be light enough for the non–history major, honoring those who came before and presenting them in a human light. The book was written with the intention of entertaining modern audiences and, maybe, challenging some local legends. The stories illustrate the travails of early settlers in the late nineteenth and early twentieth centuries. The works describe the battle with the high Colorado mountains, inclement weather and the daily struggle of life before modern conveniences for those hardy souls who took on these challenges to make a better life for themselves and their families. The area covered by the book is limited to the Upper Rio Grande and western San Luis Valley in southwestern Colorado, including old mining towns, fisheries and forgotten cabins in the woods.

Acknowledgements

We want to acknowledge the help and support of so many friends and family who encouraged us to write this book.

Special thanks to Grant Houston, editor of the Lake City newspaper the *SilverWorld*, who always printed anything we wrote and provided some last-minute information we desperately needed.

More special thanks to Jan Jacobs, Johanna Grey and Bob Seago with the Creede Historical Society, who helped us with articles, books and pictures and showed us how to preserve and scan historic photographs. You rock!

Thanks to all the great folks with the Creede Historical Society, who were always encouraging and supportive, allowing us to present our stories at their summer meetings. Also thanks to the Hinsdale County Historical Society and the San Juan County Historical Society.

Thanks to the Hosselkus family of Creede. They provided stories and family pictures for this book.

Thanks to the ladies in the clerk/recorder offices of the following counties: Hinsdale (Linda Pavich and Joan Roberts), Mineral (Eryn Wintz) and Rio Grande (Cindy Hill).

Thanks to Jim Shaffner, Richard Lilley and other Wetherill family members, who provided valuable information.

Thanks to Steve Baer, who did some final editing.

Also thanks to the Denver Public Library digital photos librarian, History Colorado digital photos librarian, Colorado Archives staff, the San Luis Valley Irrigation District staff and the Adams State University reference librarians.

And, of course, to our husband and son, Bill—thanks for your patience.

It Takes a World

The Human Side of the Rio Grande Reservoir Dam

Du${}$uring the construction of the Farmer's Union Dam (now called the Rio Grande Reservoir Dam) on the Rio Grande River, laborers from other parts of the country were contracted to come and work. As numerous dams were being constructed throughout the western United States, contractors brought in their established crews—local labor was difficult to obtain and not experienced with dam construction. Work on these dam contracts was an opportunity for men, especially recent immigrants, to make a new start for themselves and their families.

Articles taken from historical area newspapers, especially the *Creede Candle*, relate that a variety of immigrant ethnic groups arrived in that little mountain town to work on the dam. Eastern Europeans, Italians, Greeks, Swedes and African Americans, along with construction materials, came to Creede on the train and were taken up to the dam construction site by team and wagon.

> *The material for these gates consists of six car loads of steel and four cars of cement, all of which will have to be freighted by wagons from Creede to the reservoir site, about 25 miles.*

> *An extra car was attached to the inbound train, Wednesday, which contained about forty laborers for the Farmer's Union....Tex Nanse was down to Creede this week, on his usual mission it was supposed, of personally conducting a bunch of Bohunks [sic] to the reservoir. On Wednesday, he drove up the river with about forty of them, bound for the Farmer's Union.*[1]

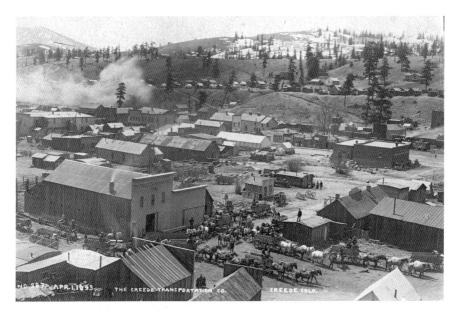

Creede Transportation Company, circa 1893. *Author collection.*

The first task in the dam construction was to build a diversion tunnel to reroute the river water away from the dam site. The manager of this contract was a Mr. Oleson, who brought in a complement of Swedes, as documented in the local newspapers:

> *Farmer's Union people…have just let a contract for the construction of a tunnel to Lumsden and Gordon of Pueblo. The tunnel is 650 feet long, eleven feet high by fifteen feet wide, and will cost $29,000.*

> *Fourteen more Swedes came Thursday to work on the tunnel up the river. Four of the first bunch went back to Denver the same day. Too much cold, too much snow, they said.*

> *A bunch of Swedes came in last Saturday to work on the Farmer's Union Project on the Rio Grande. They all got gloriously full, but managed to reach their destination safely.*

> *A fine bunch of husky Swedes came in on Wednesday to work on the San Luis irrigation tunnel.*

Rio Grande Reservoir Dam workers, circa 1908. *Courtesy of the San Luis Valley Irrigation District.*

Lumsden and Gordon of Pueblo are busy right now putting through the tunnel that will temporarily, at least, divert the waters of the river from the site of the dam. They have a large force of Swedes up there and are working two shifts per day and anticipate, so we understand, that their work will be finished within a couple of months.[2]

The contractor for the dam was another company, Ellsworth and Klaner, which brought in laborers of a variety of ethnic groups to work on the dam. The contractor also provided the extensive support system those workers required. Gathering wood for constructing corrals, cooking, heating the tents and building construction supports seemed to be performed by the Italians at the camp. "A batch of dagoes [*sic*] also came that day for the wood camp down the river (from the dam site)."[3]

Yet another ethnic group employed at the dam site was the Greeks. Their role is not clear, but they were possibly the guards of the camp, or hunters who provided meat for the camp. The following article documents their possession of guns.

Last Saturday word was received via telephone that a Greek man named George Bill, which is probably an assumed name, had been accidentally shot and very seriously wounded at the Farmer's Union reservoir. Bill was an employee of the Ellsworth-Klaner Construction Co., and worked as a laborer on the reservoir. From accounts received of the shooting, Bill was carrying an armful of firewood into a tent at the reservoir. Another Greek was cleaning a shotgun and in some manner pulled the trigger when Bill was not more than twenty-five feet away, according to an American who witnessed the affair. Medical assistance was called for…and the patient was sent to Pueblo where the agent of the Ellsworth-Klaner Co. met him and took him to a hospital. All at the scene agree that the affair was an accident pure and simple, and no steps were taken to arrest the man who was handling the shotgun.

George Bill, the Greek who was shot, accidentally, while carrying wood into a tent at the Farmer's Union reservoir on May 4th last, returned to work last Sunday from Pueblo. For a man who was injured as he was, his recovery in a short time is almost marvelous.[4]

An immigrant group not reported in the local paper was the "Orientals," presumed to be Chinese, based on their presence in the United States

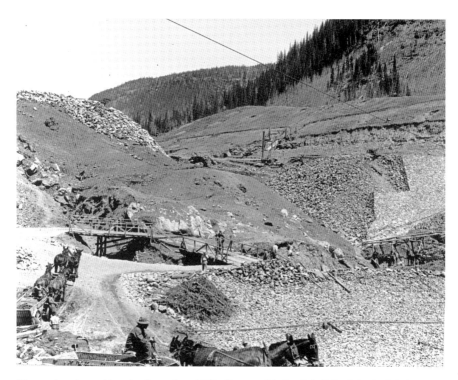

Men and mules making the dam, circa 1910. *Courtesy of the San Luis Valley Irrigation District.*

working on the railroads. There is a Hosselkus family story of Orientals working with the construction crew at the original dam in 1908 at Road Canyon (McCabe and Steen, railroad contractors). This would be logical, as many Chinese worked with the railroad crews, and after completion of the transcontinental railroad in the late 1800s, the contractors turned to dam building to stay in business. "The dam in Road Canyon…erected by McCabe and Steen [circa 1908], the big railroad contractors, has not washed out, as was erroneously reported around town."[5]

As a result of the flood that did come over the Road Canyon Dam, owner Bert Hosselkus decided that it had to be raised. Fortunately for him, the construction crew that had been working upriver was heading down the road after completing the Farmer's Union Dam. The crew boss was approached by Bert, who hired part of that crew to increase the height of his dam at Road Canyon in order to prevent future overflow of the dam during spring runoff. There, the crew camped and worked for a couple of weeks, dining on potatoes and fish provided by the Hosselkus family. Probably a few spirits were imbibed, as well.

Road Canyon Dam, circa 1913, looking southeast. *Courtesy of the Hosselkus family.*

A colorful group of Eastern European immigrants is described in "The Fourth on the Rio Grande," an article about the Independence Day celebrations held at the dam site, as hosted by the construction manager, Cy Knowles.

> *The afternoon was the time of a big dance for the Bohunks* [sic]. *They all gathered in a circle on a nice flat meadow and with one poor lone fiddler sawing away all afternoon in the hot sun, only stopping once in a great while to swat at the mosquitoes, which were almost unbearable, these folks started off on a dance…being a hop, skip and a jump motion while going around all hands joined together, every once in a while, they would all jump into the air and come down crouching. This dance lasted from early afternoon until almost dark. No women participated because none were there.*[6]

In the latter stages of the dam construction, groups of African Americans were brought to the dam site, presumably for hand labor in the finishing of the dam.

> *A bunch of chocolate drops* [sic] *were imported by the Ellsworth-Klaner Co., last Monday and were immediately taken to the upper Reservoir.*
>
> *Another car load* [about 40 men] *of chocolate drops* [sic] *for the Farmer's Union reservoir contractors, was brought in last Sunday.*[7]

Conditions at the construction site where the men lived were harsh, and the work was grueling. However, there was little option for the workers to leave. One story illustrates the lengths some workers would go to in order to escape the harsh labor.

Early one morning, Eugenia Wetherill, who lived at the San Juan fish hatchery along the road from Creede to the dam, looked out her kitchen window and saw a man approaching the house. Recognizing him as a worker from the dam, she went to the door to greet him. In his strong southern accent, he told her he was running away from work at the dam and was very hungry. He asked if she would give him some food. She quickly provided some milk, bread and a bit of leftover meat from her supper the previous night. The frightened man also told her that an armed mounted guard, who would forcibly take him back to work, was chasing him. Being the descendant of a family who had a station on the underground railroad in Kansas, she was willing to help this man escape. Fortunately, just then, she saw her next-door neighbor from Officer's Ranch (modern-day San Juan Ranch), Lora Officer, driving down the road with a load of loose hay headed for Creede. Eugenia went to the road and asked Lora if he would help the man escape. Lora agreed to hide the man in the hay and take him to Creede. They were quickly off. At Creede, Lora gave the man some money and got him on the train to Denver to start his journey home.

Shortly after the men left, the guard stopped at the Wetherill home and inquired if Eugenia had seen anyone that morning. She answered, "Yes indeed, I saw someone running over the hill that a'way," pointing to the north toward Lake City—the opposite direction from Creede! The guard trotted off on his horse toward Lake City. A smiling and relieved Eugenia continued with her household chores.

The work to build the dam required the labor and skills of many men, each of whom had hopes and dreams of adventure and making big money

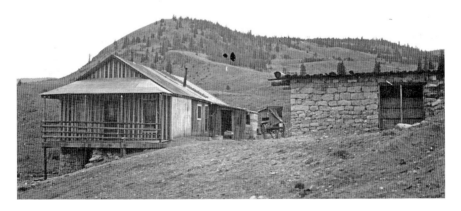

San Juan fish hatchery, circa 1913. *Author collection.*

to take home to their families. Many came, and most of them left to work on other dams or returned to their homes. The work was hard and dangerous, without the worker protections and safety controls that exist today. Minor illnesses and injuries were treated on-site by the company veterinary surgeon. Injured workers who required more skilled care had to be taken by horseback or team and wagon to Doctor McKibben in Creede, a trip of about thirty miles one way.

> *Mr. Cave, the veterinary surgeon at the Farmer's Union reservoir came down Saturday with his son who was injured by being struck on the head by a rock hurled by a blast. Young Cave was fishing when injured. Dr. McKibben put several stiches in the wound, and the young man was able to return home Sunday morning.*[8]

Time is money, and summers at ten thousand feet elevation were short, so work started early in the spring and lasted as far into the fall as possible. Conditions were thus wet and cold much of the time. This setting resulted in numerous cases of pneumonia, at least one of them fatal. For that man, his lonely grave in the Creede Cemetery is all that remains of his dreams of riches and a better life.

> *Mr. Andrew Palm, of the Farmer's Union Ditch Co., has been ill with the pneumonia for about a week.*

> *Eric Anderson, the man brought down from the big irrigation tunnel last week suffering from pneumonia, died last Saturday morning about 11 o'clock. His remains were embalmed by Undertaker Warren and held here until last Wednesday he having no known relatives or friends. Upon the arrival of Contractor Oleson from Denver, the body was buried Wednesday afternoon in the hill cemetery.*[9]

The benefits of the dam are all around, including highly productive farms with irrigation and thriving towns. So, take a minute to think of all those workers who gave years of their lives, endured harsh living and working conditions and risked many dangers to create the dam—especially those that never planned on staying here.

STAMPEDE TO BEARTOWN

Or, Muriel's Trip

The morning of the trip, my dad, Carroll Wetherill, and I caught, saddled and packed the horses for the ladies. We were leaving for a four-day, three-night trip to take Muriel Sibell Wolle and her friends to the ghost towns of Beartown and Carson. Including the two of us, there were ten riders and four packhorses/mules. Muriel was collecting information about the early mining camps of western Colorado for a book to be called *Stampede to Timberline*. She had traveled to many old mining sites and had been up on the western side of Carson—but because of the rugged terrain, she had not come up from the eastern side. Through mutual friends, Carroll, the owner of the modern-day guest ranch at Lost Trail Station and an experienced outfitter on the Upper Rio Grande, was contracted to provide the trip.

Not known to us at the time, Muriel was a famous person. Like most transplanted New Yorkers who had moved to Colorado, the beauty of the mountains struck her. She had been head of the Department of Fine Arts at the University of Colorado from 1927 to 1947. She then began traveling into deserted mountain mining towns to document the remains of fast-disappearing mining communities. Muriel authored many articles and several books about the history of Colorado's ghost towns and mining camps, including *Stampede to Timberline*, which she both authored and illustrated. The many photographs she took of this trip were not published in any of her books, which are instead filled with her lovely sketches.

The old stage route from Del Norte to Silverton ran right through Lost Trail Station Stage Stop: Freight Forwarding and Commission, established

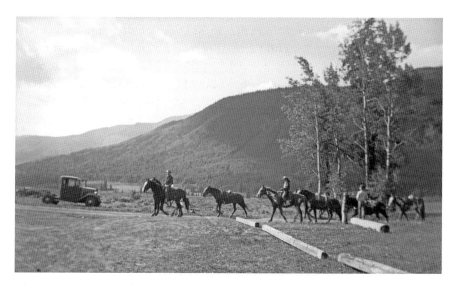

Carroll Wetherill and seventeen-year-old daughter Carol Ann bringing in horses for the trip at Lost Trail Station. *The Denver Public Library, Western History Collection, X-3567.*

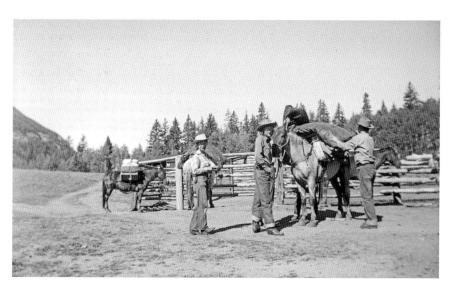

Carroll Wetherill packing one of the horses. Carol Ann is on the left, and Irene Barksdale is at center. *The Denver Public Library, Western History Collection, X-5244.*

in 1877. Lost Trail Station was host to many a weary traveler. It was a place to change horse teams and store supplies, and it had a post office. The heyday of Lost Trail Station was from the mid-1870s until the mid-1880s,

after the railroad was put into Silverton in 1882, which dried up traffic from Del Norte up the river. A second revival occurred with the mining at Gold Run/Beartown, but it was short lived, and the town declined in the mid-1890s. The old barn, corral and other outbuildings served as reminders of its glory days as a stage stop. To support the development of the old stage stop as a guest ranch, Carroll had built many modern cabins for the comfort of his visitors.

The horses were packed and the group mounted up. We left Lost Trail Station and entered the national forest. We rode through the mountain parks following the old stage route until we came down a steep hill into Brewster Park, where the old stage road joins the modern-day road along the Rio Grande as it meanders through the valley to the base of Timber Hill. As we made our way up this rocky hill, we encountered the first of many interesting historical sites. Along the side of the road was a large boulder known as "Bandit Rock," allegedly a site where bandits hid to hold up pack trains and ore wagons. On the side of the boulder are these words: "Buy your pills at the Del Norte City Drug, chaw them up, and buy some more. I will not be undersold. Mark Bidell."

After we went up the steep trail another twenty minutes, we arrived at Sweetwater Creek. This is a traditional place for people and animals alike to stop, drink the cold, clear water and have a rest. Dad and I checked the packhorse and saddle cinches, because as steep as the trail was coming up, it was just as steep on the way down the other side.

It was a beautiful day, and we were lulled into a sense of calm and complacency. As we started down the steep descent on the west side of Timber Hill, Shadrack—my favorite mule—decided to enliven our day. He pulled loose from the pack string and ran bucking wildly down into the river bottom where Bear Creek meets the Rio Grande. Shadrack ended up with his packsaddle underneath him, and the items he was carrying strewn along the trail. Carroll was quickly at his side, calmed him with a few gentle words and removed the packsaddle.

While Carroll fixed the packsaddle and collected and repacked the scattered items, the rest of us crossed the Rio Grande River to have our lunch. We dismounted and ate near the site that was formerly called Junction City, which was settled as a miner's camp to support the early prospectors looking for gold in the area. As mines were discovered farther along Bear Creek—just at timberline—the commuting distance was found to be too far, and the settlement soon moved to what was to become known as the Gold Run/Bear Creek/Beartown site.

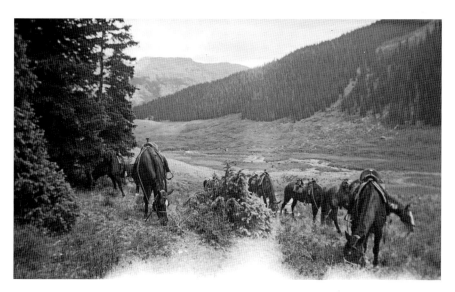

Lunch break above Junction City. *The Denver Public Library, Western History Collection, X-5245.*

After lunch, we mounted our horses for the two-hour ride up to Beartown. Muriel was a pleasure on the trip, but as we came closer to Beartown it was evident that she was eagerly anticipating the arrival at the site. As she states in her book:

> *Carroll rode back to me and said, "Stony Pass is just to the left of that peak," and with those words my excitement grew almost unbearable. For years, I'd been reading about the hardships endured by the pioneers and gold-crazy miners who had struggled over that rugged pass to reach the seductive San Juans.*[10]

She had just experienced firsthand how difficult it would have been in the early days for the prospectors and freighters who went into the San Juans to transport heavy and bulky mining equipment and machinery by mule train. The rugged road over which we had just ridden had to carry all of the men and materials to supply the high-mountain mines. As we rode into the small valley that contained the ghost town of Beartown, we saw the remnants of many years of mining and marveled at the human and animal effort required to bring all of those items up to this mountain meadow that sits just below timberline. Not everything made it in one piece.

We dismounted and started our explorations. Muriel was taking photographs, making sketches and taking copious notes. The horses were

Remnants of a wagon wreck, circa 1894, along Bear Creek. *The Denver Public Library, Western History Collection, X-5228.*

placidly grazing in the lush mountain grass. Carroll was telling Muriel the history of Beartown, which had two incarnations. In its early days in the 1890s, the area was called Bear Creek, the town was named Gold Run and the post office was designated Sylvanite, named after one of the major mines. The newspaper of day was called the *Gold Run-Silvertip*. The paper was named after the run of gold discovered at the San Juan mining camp and also after the numerous natives of the area—*Ursus arctos*, the majestic grizzly bears, which are often referred to as "Silvertip" because of their silver-tipped fur. During its heyday of mining, the area's grizzly bears were a serious problem for the miners. After several men were killed, the miners returned the favor—bear meat was a regular offering on the supper table.

In the late summer of 1892, gold was discovered in the Bear Creek area, very near the surface of the ground, called "grass roots." The Good Hope mine sent out two tons of high-grade ore to Denver before the snow became too deep. The ore was packed on mules and hauled to the base of Timber Hill, transferred to wagons and eventually put on the train in Creede, almost fifty miles from the mines. The assay results of that first load of ore started the rush that occurred in the spring of 1893 to the new San Juan Gold Camp.

The prospector is heading our way, and he is after gold. It is here for him and in good quantity—Big mines at Grass Roots, many promising prospects located.[11]

As the miners flocked to the area, the nearby towns competed for their outfitting business. Miners needed to purchase shovels, picks, ore bags, claim markers, clothes, food and sundry supplies, possibly horses or mules—it was a big business for the merchants of towns. The historic route from Del Norte through Creede into the Upper Rio Grande had been used for many years, was well established with a (relatively) good road and many traveler accommodations and did not involve crossing the divide as did the route up from Silverton. However, the route from Silverton through Cunningham Gulch on the western side was much shorter, although significantly steeper, and with minimal accommodations along the way.

> *To reach Gold Run, come by way of the Denver and Rio Grande railroad to Creede or Silverton. It is about 55 miles by road from Creede, and 18 miles from Silverton. You can take a stage or procure horses or mules in Creede. The trail is not good from Silverton, because of the snow laying on the range, and going over Stony Pass [12,592 feet]. Prospectors, however, can outfit at either point and make it with burros. From Creede the time is about one-half longer than from Silverton. By horse or stage, it can be made from Creede in from a day to a day and a half.*[12]

As a growing mining camp with a newspaper publication that started in June 1893, the next step of civilization was obtaining a post office. In those days, before computers, cell phones and social media, all communication was through the U.S. mail. It was imperative for every small hamlet; stage stop or mining camp to have a post office to maintain communications.

> *A petition has gone in for a post-office to be called Gold Run. Service is asked by star route from Creede.*[13]

In order to deliver rural mail, the postmaster-general would lease delivery contracts to the lowest bidder who tendered sufficient guarantee of faithful performance, without any conditions, except to provide for due celerity, certainty and security of transportation. These bids became known as "celerity, certainty and security bids" and were designated on the route registers by three stars (***), thus becoming known as "star routes."[14]

Apparently, the Gold Run post office name was not approved, but a post office was later established called Sylvanite, named after one of the major mines there, with Ira A. Scott as postmaster. There was significant competition between Silverton and Creede to host the mail route, supply the

miners and ship ore. Every edition of the camp's newspaper has competing articles about the support and interest in outfitting the miners heading to Gold Run.[15]

> The petition also requested daily mail service from Creede, about 55 miles away, on the same side of the range, whereas Silverton—the other nearest town—is inaccessible except for the summer months.[16]

In June 1893, it was estimated that there were about three hundred people in the camp. About halfway along the road from Creede to Gold Run was Lost Trail Stage Stop; an appeal was made to support the miners on their way through from Creede for a place to stop and eat. Harlow J. Holdrege, postmaster at Lost Trail Station, was likely the man who started up the restaurant.[17]

> Joe Vert and Wing and Sandusky are running regular stage lines between Gold Run and Creede, and come in with a full load every trip. Every day brings its quota of new settlers, and if the mines turn out half as well as they promise, it will be a camp of 3,500 before winter.

> A plea is made to establish a dining station at Lost Trail. It would shorten the road a whole lot if the comers-in could leave that point with their vest buttons tight.

> A butcher shop and restaurant has been opened at Lost Trail, greatly increasing the convenience of travelers coming from Creede.[18]

Life at about eleven thousand feet in the San Juan mountain range was always a battle against nature. Summers were short and winters long. Hay and grain for animals and provisions and supplies for people were a constant source of concern—and a great source of income to purveyors. The snow in the winter could be up to twenty-five feet deep and the roads impassable for many months of the year, except by snowshoe. Provisions had to be well stocked for the winter months, and cutting and storing firewood was a constant job.

> Both Creede and Silverton will celebrate the Fourth. Gold Run will saw wood.

> The camp is steadily growing. More prospectors are coming in than going out. And the town is taking on shape; two stores and a saloon, with a number of prospector camps, assay office, and surveyors offices are collecting

in the park below the falls. If the present rate is kept up, Gold Run will be a respectable size camp before snow flies.[19]

However, the predicted stellar camp was not to be. With the repeal of the Sherman Silver Act, the price of silver dropped sharply, and most of the miners abandoned Gold Run. Mines throughout the West were virtually abandoned overnight—mail was left in post office boxes, food on the stove.

The Sherman Silver Purchase Act of 1890, signed by President Harrison, required the government to buy 4.5 million ounces of silver per month. The economy of the United States at the time was stagnant, and politicians had created an artificial market for silver. The price of silver shot up from $0.84 to $1.50 an ounce, which led to the frenetic development of silver mines throughout the western United States, especially Colorado, which produced over 60 percent of the nation's silver during these years. The circulation of silver led to a decline in the value of gold-based money as investors turned in the new silver notes for gold dollars. The inflated price of silver affected the world economy, which destroyed worldwide confidence in the dollar, and there was international pressure for the United States to address the artificial price.

On August 8, 1893, President Cleveland and Congress repealed the act, effectively bringing the price of silver down from $0.83 to $0.62 an ounce in one four-day period. Banks closed their doors, and real estate values plummeted, resulting in the immediate abandonment of many marginally producing mines. At the same time, this action dried up the supply of development money for new explorations for precious metals. The repeal of the Silver Act was felt across the country, especially so in Colorado. Many miners in Colorado headed to Denver and larger cities in an attempt to find work to support themselves and their families, causing an overburden to charitable organizations and other socioeconomic effects.

The July 1, 1893 edition of the *Gold Run-Silvertip* was the last of that year, as the mining town of Gold Run was effectively abandoned because of the panic. But in the spring of 1894, miners had found their way back to Gold Run, and the newspaper was again in operation. Because of the gold content in the ore, there was still profit to be made. The price of gold started to rise shortly after the repeal of the Silver Act, but since Gold Run was under several feet of snow and the roads were impassable, it was early spring before any work commenced at the camp. Miners, being a resilient lot, again were swarming to the little mining camp at Gold Run.

The Bear Creek Mines
The rush is on and can't be headed off
Prospectors Outfitting Daily for the Great Gold Camp—Two Hack lines
put into operation today—the Road Assured—Ore hauling to commence
next week

Bear Creek is the Mecca to which all eyes of gold hunters in this section of the country are turned. Today the great coming gold camp is on everyone's tongue, and travel is setting in from all directions and parts of the state. Billy Kingman snowshoed in from Silverton, and he says 200 men are waiting for the snow to leave to come in from that section. All the talk in Silverton and Durango is of Bear Creek. A Post-Office has been established with the name of Sylvanite, with Ira A. Scott as postmaster. Had not the panic came [sic] just when it did, it is possible the State would be talking today of the wonderful mines at Bear Creek. Ore is of a tellurium character running 205 ounces of silver, 210 ounces of gold and 4% copper to the ton, but it shows more pockety and less continuous ores chutes. Fultz and Higginbotham have a quantity of lumber at Lost Trail Stage Stop, which they plan to bring up.[20]

Sylvanite ore is a silver gold telluride, and it is the most common form of gold in the San Juans; gold is usually found elsewhere as free gold. Sylvanite is one of the few minerals that is an ore of gold, and it is one of the most common gold-bearing minerals. It was this tellurium ore that was taken from the area mines, as there is no free gold to be found in the Bear Creek area.

During the summer of 1894, the area mines produced high-grade ore, but because it was mostly found in pockets, and not in many veins, the easily accessible (grass roots) ore was soon gone. Shafts drilled in mines often filled with water, which was difficult to keep pumped out. Contributing to the short life of the Bear Creek mines were the following factors: the effort required to drill and blast, without any real vein to follow; the high altitude; and the short working season. After the summer of 1894, Gold Run was not enough of a town to warrant either a newspaper or a post office, the Sylvanite Post Office being in existence from September 20, 1893, to October 26, 1894, and the nearby Lost Trail Station Post Office from June 27, 1892, to May 10, 1894.[21]

Over the next few years, interest in working the mines waxed and waned; only some of the richer ones continued to produce some small amount of ore. Many miners left the area for better opportunities, returning if there

Lost Trail Station horses grazing in the remains of Beartown. This view looks south toward the Sylvanite mine site. *The Denver Public Library, Western History Collection, X-5236.*

was a report of new finds of richer ore. Additionally, traveling to the mines was done coming up Cunningham Gulch from Silverton, and travel shifted away from Creede, which followed the old stage route through Lost Trail Station. The road from Silverton had been significantly improved and was much shorter than from Creede, and there was a good rail line into Silverton.

> *Ira A. Scott, who had charge of the Good Hope mine at Bear Creek last season, and who has wintered in Denver, left that place a week ago for his old stamping grounds and will commence work on the Sylvanite and Good Hope mines, in which he is interested with Judge H.T. Well, at an early date.*

> *Sunday last four tons of supplies were packed to the Good Hope mine at Bear Creek by the pack train of A.R. Powers.*

> *C.F. Holley, one of the Bear Creek pioneers and locator of the Gold Bug and Repeal of that camp, but of late an honest rancher of Farmington, N.M., was an arrival on Wednesday's train.*

> *Since the recent rich strike in Bear Creek attention is being attracted that way, and several old abandoned claims over there will be taken up and worked just as soon as the snow leaves the ground. Of the old-time producers of Bear Creek: the Good Hope, Little Giant, Bonita, Gold Bug and Repeal*

properties will be worked. It is quite likely that they will sink on the vein which contains exceedingly rich Sylvanite.

At the Gold Syndicate Mining Company's property at Bear Creek, 4-oz gold ore in quantity is being stoped from the Repeal lode.[22]

The renewed mining efforts were short lived, as the political powers back East once again created the death knell for western silver mines. On March 14, 1900, Congress ratified the Gold Standard Act, signed by President William McKinley, which officially ended the use of silver as a standard of U.S. currency and established gold as the only standard. The price of silver again crashed, ending the lives of the western silver mines that had managed to struggle through the Panic of 1893. So, although the Bear Creek mines produced some gold, they depended on the silver income to be profitable. Everything that had been shut down for the winter of 1899–1900 was left that way and not restarted.

A genetically distinct population of San Juan Mountains grizzly bears once inhabited the southwestern mountains of Colorado. There are many stories of miner-bear interactions, some of which were fatal for the miners and others for the bears. Bear meat was a staple for miners, the animal being large enough to provide for many meals. Reducing the bear population also allowed more of the local ungulates to be harvested by the miners.

The bears, which have heretofore held the country as their very own, don't propose to surrender without a struggle. They are showing themselves about camp uncomfortably often. The other night, one passed through town and left his mark as a warning to trespassers.

Doc Barnes returned from his bear hunt yesterday, but the bear saw Doc first. The first mile was made in 3.08 minutes, as Doc avoided a handicap by throwing his gun and coat away. It was a Silvertip, and Doc is not.[23]

As humans encroached on the natural habitat of the great bears, the animals were increasingly hunted, to the point of extinction. Ernie Wilkerson, government hunter and trapper, killed the last known Silvertip in 1952, but there are stories of a female being killed near the Colorado–New Mexico border in 1979. The only remembrance of the great bears in the area is the enduring name of Beartown.[24]

For many years, the United States maintained the price of gold at $20.67 per troy ounce, guaranteed, regardless of the cost of production. On June 5,

1933, under President F.D. Roosevelt, the nation went off the gold standard and later set the price of gold at $35 to the troy ounce. The increased price of gold, combined with lower wages and material costs prevailing during the Great Depression, caused gold mining to become attractive again.[25] Old mines reopened, and currently operating mines expanded.

In the 1930s, the second incarnation of Beartown occurred. Maude Russell, alias "Beartown Maude," was a transplanted Creede lady of means and entrepreneur extraordinaire who was instrumental in reopening the Beartown mines. When Maude arrived in Creede, she purchased and operated the Creede Hotel and before long learned of the rich Beartown (formerly Gold Run/Bear Creek) mining area. She quickly secured eastern investors to provide funds to reopen and operate the mines. Many of the buildings from the 1890s were renovated for more modern use, and the ore trucks rumbled up and down the road right through Lost Trail Station. No more mules. Miners were able to get into Creede for supplies and recreation on a regular basis.

The mines operated from approximately 1937 through the fall of 1941, when they closed for the winter. As the United States became involved in World War II, the miners were called to duty, and the mines were never reopened. Because of the duration of the war, it became apparent to Beartown Maude that the mines would not be revived, so she asked Carroll to go up to the assay

Beartown assay shack (*left*), circa 1939. *The Denver Public Library, Western History Collection, X-5239.*

shack, take out all of the chemicals and bury them. He had an old prospecting hole of his own that he thought would be a perfect disposal site. One day, Dad and I rode up to Beartown, took the jars and containers of assay chemicals out of the buildings, placed them in his old prospecting hole and covered the entrance—where they remain to this day.

An uneventful night was spent at Beartown in the hotel/boardinghouse, followed by another day of exploring and storytelling around the Goldbug at Kite Lake, the Sylvanite and the Good Hope mines.

A second night was spent at the hotel/boardinghouse before we were ready to leave Beartown. We packed up and started on our way over to the old mining camp of Carson. The night's camp was along Pole Creek, at a camp Carroll had made while the group had been exploring.

> *He had pitched two tents and had unpacked everything and stowed it neatly away. I watched fascinated while he unsaddled the horses and turned them loose, hobbling those who were known to wander too far away. The saddles and blankets were placed in a long row over a fallen tree ready for the morning's ride.*[26]

On the third morning, we awoke to a dreary day. It was raining as we rode over to Carson. By the time we arrived, it was raining hard, and we

Beartown hotel/boardinghouse, circa 1939. *The Denver Public Library, Western History Collection, X-5241.*

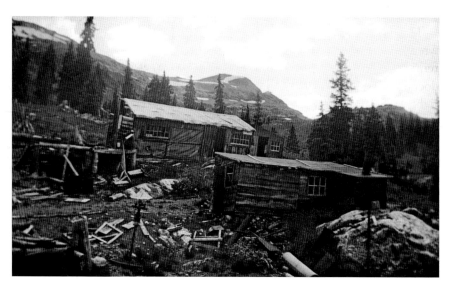

Buildings near the Sylvanite mine, Beartown, circa 1939. *The Denver Public Library, Western History Collection, X-5237.*

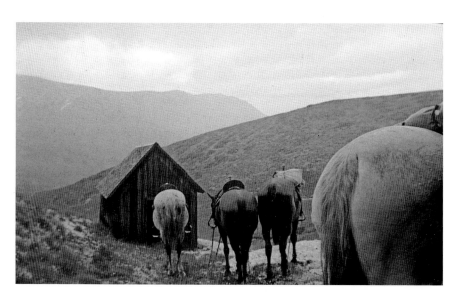

Patient horses standing in the rain at Carson, waiting for the group to mount up. *The Denver Public Library, Western History Collection, X-3021.*

took shelter in a little shack. After some time, when the rain did not abate, we decided to put our slickers back on and head down the trail to the home corrals at Lost Trail Station.

The trip was essentially uneventful and unremarkable—no major wrecks, wild animal encounters or other excitement. However, I will always remember the pleasant woman who was so enthusiastic about her work documenting the historic mining towns before they disappeared. She was right. Within a relatively few years, all the remains of Beartown were gone. Whether recovered by the owners, stolen by scavengers or taken as souvenirs by tourists, the results were the same. Today, the patch of lush, high-mountain grass would not be recognized as the former site of Beartown, unless you knew where it was. Modern-day travelers through the mountains have arrived footsore and weary at Lost Trail Station, telling us that they were headed for Beartown and believing that they must have missed it. We sadly inform them that they probably walked right through without knowing it was there. However, if you listen carefully, you can hear the ghosts of Beartown whisper quietly, "Thanks for saving our memory, Muriel!"

CHICKENS RATTED ME OUT

Or, the Still on the Hill

One summer day, Shirley Wills returned to the ranch house from the mailbox five miles away and handed his wife, Anna, an opened letter. The letter was from Shirley's cousin, Bob Wills, the leader of a western swing band, the Texas Playboys. Bob and the band wanted to come to the S Lazy U Ranch in Crooked Creek Canyon for a few days of horseback riding, fishing and just lazing around. In return, they offered to play a Saturday night dance in the new dance hall that Shirley had built on the top of the hill. At that time, one way to bring in much-needed cash was for a rancher to hold Saturday night dances for the tourists, or, as Shirley always called them, "dudes." There was a cover charge for the dance, and a midnight supper could be purchased after an evening of dancing. These events were a time for ranchers—along with their help, as well as the dudes and townsfolk—to revel and dance the night away. Shirley and Anna owned and operated the S Lazy U guest ranch, with two well-stocked lakes for fishing—a major attraction for tourists.

Shirley was the oldest of three boys and a younger sister, Ina Wills. The children had grown up on a ranch near the town of Hooper, Colorado, down in the San Luis Valley, but the family had taken working vacations into the Upper Rio Grande for many years, so Shirley knew the area well. The Wills family, depending on nature's bounty to supplement their diet, would pack up cooking stoves and fishing equipment into their horse-drawn wagons and take a two-day trek into the mountains near Antelope Springs along Texas Creek. Once there, the family would gear up for a fish canning

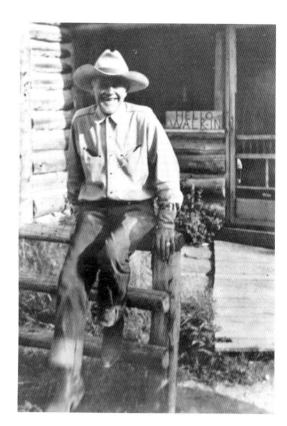

Right: Shirley Wills at the front door of the S Lazy U ranch house, circa 1951. *Author collection.*

Below: The Wills children (*from left to right*), Ina, Horace, Frank and Shirley, circa 1902. *Author collection.*

marathon. The men and boys would catch and clean fish, and the women would cook and can the fish, with about four hundred quarts of processed meat as their goal. It would take about six filleted fish to make a quart. Meat

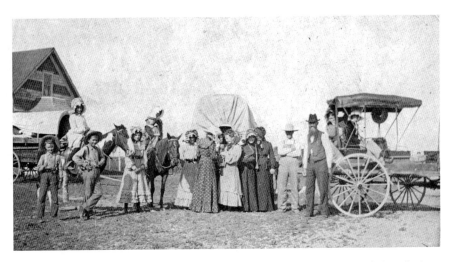

Wills family fish harvesting trip, near Antelope Park along Texas Creek, 1899. *Author collection.*

was a constant challenge for poor farm families, as they kept their farm-raised animals to sell for hard cash to use for essential supplies. Having been the eldest child growing up on the ranch, Shirley was no stranger to hard work—which the dude business certainly was. Therefore, he was always looking for ways to supplement income at the S Lazy U.

> *The Wills camping party returned from Antelope Park the first of the week, after a stay of ten days. There were over thirty in the party, and they caught 2,400 fish.*[27]

There was no road leading up to the dance hall. Guests had to park their vehicles below the knoll where the dance hall was built. Shirley's reasoning for this arrangement was that he knew some of the dance patrons would be surreptitiously drinking, although no alcohol was allowed in the dance hall. He reasoned that if dancers were out and about on the grounds, too drunk to make it back to the top of the hill, they could not interrupt the dance.

The appointed Saturday had arrived, Bob Wills and his Texas Playboys could be heard tuning up their instruments and darkness was coming fast in Crooked Creek Canyon. Anna and the girls helping her were busy preparing the midnight meal: sandwiches, salads, two-layer cakes, pies and lots of coffee. The phone rang, and Shirley answered. A voice told him the load of corn would arrive in about an hour, after darkness had fallen. Shirley knew he had to get the pack mules saddled and tied in the corral so that the corn

S Lazy U dance hall on the hill, circa 1931. *Author collection.*

could be carried up the hill to the still. Shirley's workmen, John Kirby and Dan Cavanaugh, would have to put the burlap sacks of corn on the mules and get them up to the still on the opposite side of the canyon unnoticed by anyone. Shirley sent John up the hill to alert the Still-Man that a corn delivery was coming that evening.

Before long, headlights of cars could be seen coming up Crooked Creek Canyon. Car after car arrived, and dance patrons headed up the hill. The band could be heard playing its signature song, "Take Me Back to Tulsa." The corn truck arrived, and, as usual, the driver parked in back of the corral so as not to be seen. In the darkness, the Still-Man, Shirley, Dan and John loaded the mules. What none of the men realized was that two of the burlap bags had small holes in them; corn kernels trickled out all the way along the trail up the hill to the still. Once the mules were brought up to the still site, Shirley and his men went back down to the S Lazy U, leaving the mules, their bags of corn and the Still-Man to his business.

Around 11:00 p.m., a man who was in his cups and could not navigate the trail back up the hill to the dance hall barged into Anna's kitchen to give her a hug. Such behavior was a strict no-no. Anna grabbed a No. 10 cast-iron skillet from its hook on the wall and swung it hard against the side of his head. Down the Skillet-Man went. Anna told her helper Norma to go find

S Lazy U main ranch house, with kitchen in the foreground, circa 1931. *Author collection.*

Shirley. Shirley and Dan came running and, with no ceremony, took the Skillet-Man out behind the chicken coop and dropped him there to sleep it off. At some point toward morning, the Skillet-Man came to and staggered around, trying to find the door to the outhouse. Instead, he found the door to the chicken coop. Yanking it open, he encountered Anna's pet bantam roosters, which aggressively flew at the man, who in his unsteady state hit the ground again. The excited chickens blasted out of the coop over his unconscious body and eventually found the trail of corn.

The dance was over, and the midnight supper had been a huge success—nearly everyone had stayed to eat. By 3:00 a.m., the guests had departed, and the ranch was quiet. Anna lay down for a few hours' rest before getting up to start breakfast for the ranch hands, the departing Bob Wills and his band. In the early morning hours, as she roused herself and looked out of the window at the sunrise, Anna saw her beloved chickens out across the canyon, seemingly following a trail up the side of the wooded hill. Alarmed for the safety of her birds with coyotes all around, she headed out the door to chase them back to their coop, grabbing a broom to take along in case the roosters flew at her.

Up at the still-site, the quietly sleeping Still-Man was awakened by Anna charging up the hill, shouting and waving her broom as she came up the trail. The mules, which had been tied to trees after the bags of corn were unloaded the night before, were as startled as the roosters—which had lost no time following the corn to the still—and now started fighting. Anna was waving her broom and shouting, roosters were squawking and flapping, mules were braying and the Still-Man fell out of his hammock. The commotion caused the mules to break their tie ropes. Freed of restraint, they galloped back down the hill to the barn for safety. Quickly assessing the situation, Anna ordered the newly wakened Still-Man to capture the roosters, put them in the burlap bags and carry them back to the chicken coop while she chased the hens back down.

In the meantime, the Skillet-Man had awakened from his stupor and this time found the outhouse. Although he had a thunderous headache and a bloody ear, he remembered having a good time at the dance. He didn't know what happened to his head, but he seemed to recall some huge birds attacking him in the dark. He managed to find his old pickup truck and headed down Crooked Creek Canyon toward Creede.

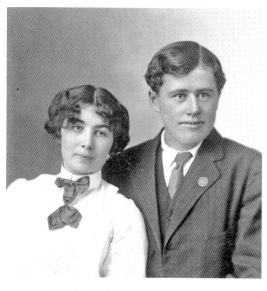

Anna and Shirley Wills wedding photo, circa 1919. *Author collection.*

Anna locked the chickens back in the coop and was soon in the kitchen preparing breakfast. By midmorning, the visitors were packed and ready to leave. As Shirley was telling his cousin and the band goodbye, the Still-Man arrived and handed a couple of jugs to the men. Bob Wills and his band always enjoyed the fringe benefits of playing a dance at the S Lazy U.

A rather unusual weekend for the Upper Rio Grande, but not so in Crooked Creek Canyon. After the departure of the band, Shirley spent a long morning explaining his business arrangement with the Still-Man to Anna—hoping she didn't have a skillet handy.

4

FROM SHILOH TO THE RIO GRANDE

Or, He Was Killed in a Bar Fight

Charlie Jennison pulled his team to a stop at the new settlement of San Juan City, which was the county seat of the recently formed Hinsdale County, Colorado, along Clear Creek near the Rio Grande. Charlie (also known as Charley or Chas) Jennison and his wife, Irene, were moving to Del Norte for the winter from their homestead twenty miles up the Rio Grande River to the west of San Juan City. After greetings all around with friends Anna and Ben Taft, and Ada and Clarence Brooks, and an invitation to share supper with Anna and Ben, Charlie went to unhitch the team and feed and water the horses for the night. By the time he was finished with his chores, the lamps were lit in the house, and as he opened the kitchen door, he could see supper was ready.

That evening, there was good conversation into the night—war stories, of course; both Ben and Charlie had been in the Union army. Ben, a second lieutenant at Vicksburg, was wounded in the Battle of Pea Ridge. Charlie had been in the battles at Shiloh and Lookout Mountain and then on to the battle for Atlanta. After the war stories, conversation centered on the recent summer and the many people who had passed by San Juan City and Jennison's new homestead up the river that Jennison had named Chamiso, which later became known simply as "Jennison's."

People were headed for the newly discovered rich mineralized Baker's Park area (Silverton), but not all wanted to prospect for gold and silver. Some were merchants, with wagons loaded with everything they needed to start a store: food, mining supplies and liquor. Among those traveling over

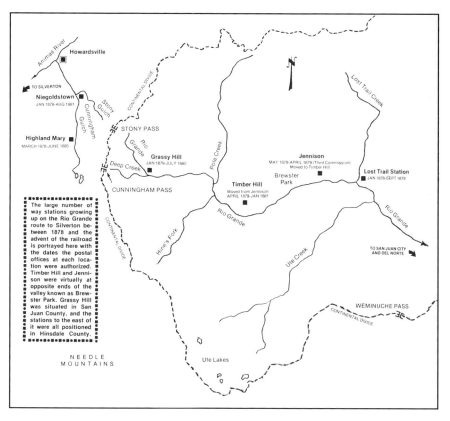

Way stations along the Rio Grande route to Silverton area mines, circa 1878. Many More Mountains, Vol. 2: Ruts into Silverton. *Allen Nossaman.*

the track that summer—hardly a road—was William Henry Jackson, a photographer, and his companions who were traveling to the Mancos area to photograph the Anasazi ruins. From the diary of Jackson is a description of Irene Jennison. Jackson camped near Jennison's cabin for several days and took his meals with them. In his diary, he remarks that "the lady of the establishment with her many smiles and dimples was more comely than most women in this rough country." The evening at San Juan City closed with a good talk about the many people expected in the summer of 1875 and how business would prosper.[28]

The next day, November 8, 1874, Charlie Jennison filed his 160-acre homestead claim, No. 35, at the cabin that served as the Hinsdale County courthouse at San Juan City, signed by clerk/recorder W.H. Green and deputy recorder Henry H. Wilcox. Charlie claimed the mountain valley now known as Brewster Park on the present-day four-wheel drive road from

Creede to Silverton. The description of the homestead filing showed he claimed the land in the valley from cliff to cliff on the east and from cliff to cliff on the west—a two-mile stretch of meadow only a half-mile wide. No traveler would be able to continue west on to Stony Pass or Silverton without going through Charlie's place—and his toll gate.

Del Norte was still two days' travel away, so early the next morning, the Jennisons were on their way downriver to the Wason ranch, where they would stay their second night on the road. By the next night, they would be at their winter home in Del Norte.

Charlie Jennison was born on September 2, 1841, to Henry Quartus Jennison and his wife, Mary Beal, at Muscatine, Iowa. Charlie was the fourth child in a family of eight children and one of only four children to live to adulthood. The Civil War came, and Charlie enlisted in the Union army, where he became a courier for General Joseph Hooker. After the war, Charlie Jennison, along with his parents, moved to the Colorado Territory. They settled around Golden City, then the capital of the territory, now known simply as Golden. In early September 1868, Charlie purchased the Garbarino's Saloon and Confectionary store in Golden City from the Garbarino brothers, who had constructed the building the year before.[29]

> *I find Colorado well represented here. Among the Coloradoans is our old friend Charlie Jennison of G.C. [Golden City], who is running the Magnolia and doing a flourishing business—long may he do so.[30]*

Although his business was thriving, Charlie wanted more excitement in his life. Therefore, in 1870, when the Colorado territorial legislature created two new counties—Greenwood County on the Kansas border, with Kit Carson as its county seat, and Elbert County, with the town of Elizabeth as its seat—Charlie managed through the political influence of his brother-in-law to be appointed sheriff of Greenwood County.

> *Kit Carson was a peaceful town and in good order thanks to the energy and activity of Sheriff Jennison and his Deputy, M. Desmond. They are worthy officers and by their watchfulness are rendering Kit Carson noted for quiet and good order.[31]*

Established in 1870, Greenwood County didn't develop its predicted population once the rails moved west and the legislature, by request of citizens, divided the county between Bent and Elbert Counties in 1874.

CAPITOL
RESTAURANT,

Harrison's Block,

Golden City, - - COL

———

CHARLEY JENNISON, Prop'r.

———

**I HAVE PURCHASED THE STOCK IN
trade and goodwill of this well-known and**

FAVORITE ESTABLISHMENT

**of the late proprietor, Charley Garbarino, and
invite my friends and the public to "SMILE"
upon me.**

*Choice Wines, Liquors, Cigars, Confec-
tionery, Toys, etc.*

**on call. Come and see me.
CHARLES JENNISON
Proprietor**

From the *Colorado Transcript* newspaper, October 21, 1868.

Greenwood County lasted a mere four years. Charlie saw the handwriting on the wall and knew he had to find another employment avenue.

Hearing the stories of the discovery of gold and silver in the San Juan Mountains near Silverton, Charlie decided that he would head that way—not to mine, per se—but to supply the miners. With no roads in the area, the transportation of foodstuffs, mine supplies and mail to the area was difficult, as was shipping ore and bullion out along the treacherous trails.

Pack animals had to carry materials to and from the mines at Silverton to the next freight station. Charlie was convinced that there was a fortune to be made in supplying miners and freighters.

Therefore, in late 1873, he made a quick trip to San Juan County and decided he would like to homestead along the Rio Grande some one hundred miles west of the town of Del Norte. Subsequently, early in the spring of 1874, Charlie and Irene Jennison were on the road to Del Norte and beyond. He was worried that someone would occupy the piece of land he wanted before they could arrive to claim it. His was the first wagon on the road that spring. No one was at the site, and Charlie's first thought was to build a cabin at the east end of the valley by a stream that came off of Pole Mountain into the Rio Grande. The cabin was just finished when the first freight wagons, horseback riders, walking miners and carriages showed up headed for Silverton. The Jennisons were so busy that summer they didn't have time to build their fence and toll gate. Everyone stopped to say hello, ask for their mail, eat a bite, purchase supplies, camp and rest their animals before the steep climb over Timber Hill.[32]

The Jennisons stayed at their ranch until the cold weather and a sprinkling of snow told them they should leave; by then there had been no travelers on the road for nearly a week. They packed up, leaving their cabin unlocked with a supply of wood and kindling inside, in case someone was stranded on the road. Then they left for San Juan City and from there on to Del Norte to spend the winter.

The winter of 1874–75 went well, and like many others, the Jennisons made plans to follow the snow line back up the mountain and get to their homestead as soon as possible in the spring. However, the snow pack was heavy, and their departure was delayed. In March 1875, a day of horse racing was planned at Del Norte. The racetrack was simply the wagon road that went west from town. Then, as now, an outcropping of rocks stood about four miles west of town. The outcropping was called "Judges Rock." During races, four men who agreed not to bet on the race or have a horse in the race would go out to the outcropping and sit, each facing in a different direction, and make sure the horses came out to the rock, around it and back on the road. The turnaround point for the race could not be seen from town, hence the need for judges stationed on the rock.

The first horse race of the season was held on March 10, 1875. Now, the race over, evening had come and men were gathered in saloons to talk about the race, the betting and about anything else of general interest. Charlie Jennison was among the crowd at a saloon known as Tom's Place. The

crowd was drinking, and there had already been several altercations among the losers and winners of the races.

> *Our normally quiet and peaceable town was on last Monday night the scene of a bloody and fatal tragedy—the first which has occurred in our midst since the town was incorporated. In a quarrel, growing out of a trivial occurrence, so far as is known, the deadly pistol was brought into requisition, and a strong and healthy young man, who had before him the reasonable prospect of many years' life was suddenly, almost instantly ushered into eternity. One witness testified as to hearing an altercation between the two parties on the outside of the house some time previous to the fatal encounter, during which abusive language was used.[33]*

That evening in the saloon, Charlie Jennison began a scuffle with a man called Buckskin Tom Chandler, not the owner of the saloon but an itinerant miner from Wichita, Kansas. Buckskin Tom apparently didn't want a quarrel, but Jennison threw him down and banged his head on the saloon floor a few times. Tom asked to be let up, which Jennison did, but Jennison then threw off his coat, dropped his gun belt to the floor and advanced toward Tom with a set of brass knuckles on his hand. Buckskin Tom retreated as best he could, but Jennison kept coming toward him, at which point Tom drew a revolver and fired, killing Jennison instantly with a shot to the heart. Charlie was thirty-three years old. The story spread rapidly through the state; almost every newspaper in Colorado had an article about the shooting.[34]

It was known that Buckskin Tom was a former Confederate soldier. As Charlie was a former Union officer, there may have been some preexisting bad blood between the men. Additionally, Charlie had killed a man in Abilene, Kansas, some years earlier; since Tom was from the Wichita area, it is possible that they had some previous negative relationship related to that killing, which led to the rapid escalation of the fight in Tom's Saloon. Fisticuffs over a bet won or lost on a horse race were common but not usually fatal. Charlie had been a sheriff, but he was also known to have a hot temper, quite possibly running in the family.

> *Jennison was a warm-hearted, accommodating man, but, in mining parlance, "was on the shoot," especially when under the influence of liquor. He leaves a young wife, who has the sympathies of the whole community.*

There seemed to be a sanguine thread with the men of the Jennison family. Charlie's father was killed down on the Fontaine, near Pueblo in 1866. Two or three years ago, the son Charles killed a Texan at Abilene.[35]

After the shooting of Jennison, the saloon was quiet, except for the weeping of Irene, while the local sheriff selected a posse. Buckskin Tom was already well on his way out of town, seen riding east. He was never apprehended, although some would say that his action was in self-defense, and local law enforcement was thus slow to respond. From a newspaper article about the event, it also seems that Buckskin Tom was not one to be trifled with; possibly, the lawmen were not eager to confront him. He moved to Denver and was recognized once, but not apprehended.

Tom disappeared in the canyons and lonely places of the then great, lone land and was not followed by anybody. Nobody wanted to tree him. Charlie Jennison was too liberal in making his fight, or the killing would have been the other way….Buckskin Tom was recognized once at the Corn Exchange Saloon on Blake Street in Denver. However, the crowd gathered around him when officers tried to arrest him, and he made his escape.[36]

After burying Charlie in the Del Norte cemetery, Irene Jennison was making plans to return to her homestead on the Upper Rio Grande. She resumed operations at the homestead in the early spring and ran the little store she had established as well as cooked for the travelers during the summer of 1875.

The next and last stopping place this side of the range is Mrs. Jennison's ranch. This is five miles beyond Lost Trail. Mrs. Jennison keeps a regular storage depot, besides accommodations for travelers. This has been the liveliest camp on the Rio Grande this summer, as most coming this way, packed their necessary articles on their animals and left their wagons and all goods that could be spared there. And there have not been less than twenty-five vehicles of various kinds here all summer.

Theodore Schoch runs a "train" of forty jacks from here [Silverton] to Jennison's, Antelope Park, and the different mining camps in these mountains. When they and four or five hundred others get together in this little park, their mellifluous voices waken the echoes, startle these solitary places, and ring out dolefully on the night air.[37]

With the loss of Charlie, good friend Anna Taft had encouraged Irene to apply for a post office designation at Jennison's to augment her income. The Jennison Post Office had been assigned to Charlie starting in January 1875, but with his death, Irene had to apply under her own name. She was granted operation of the post office in April 1875, which she discontinued in December 1875 to go live in Del Norte for the winter. She then had to reestablish herself as the mistress of the Jennison Post Office in the spring of 1876, and she ran it that summer until she sold the homestead.[38]

There are three new postmistresses in Colorado; viz: Mrs. M.A. Hall, Hillsborough, Weld County; Mrs. Irene Jennison, Jennison, Hinsdale County; and Mrs. Mary Day, Lincoln City, Summit County.[39]

Hundreds of people were traveling the road to Silverton from Del Norte in those years. Among those with mining interests in the San Juan County but who lived elsewhere was Peter Becker, the sheriff of El Paso County, Colorado. Handsome Peter Becker took more trips than were absolutely necessary to pass by Irene's stage stop, and a romance blossomed. Irene ran the Jennison operation during the early summer of 1876, but in the fall, she sold the property to Joel and Lucy Brewster (hence the enduring name of Brewster Park) and purchased a small ranch and stage stop some thirty miles east of her original homestead. Irene ran the new stage stop—where the Broken Arrow Ranch is located now—in the fall of 1876.[40]

On December 16, 1876, Sheriff Peter Becker of El Paso County married Mrs. Irene Jennison of Del Norte in the presence of close friends and relatives.[41]

Charlie Jennison's mother lived in Golden City, and she could not get over the loss of her favorite son. Each year at the fair held at the Presbyterian church, she brought a piece of shrapnel from Shiloh and a stone pipe Charlie had carved at Lookout Mountain, Tennessee—keepsakes from her son's Civil War years. In her grief, Charlie's mother maintained a vendetta against the local newspaper editor for his coverage of Charlie's death. She felt that Charlie had not been portrayed as the wonderful man he truly was.

Mrs. Jennison has opened a terrific war on me. The published article of Charlie's death was made up from southern exchanges, by my night editors, and I never heard of the occurrence until I saw it in the NEWS, but the good old lady, goaded by her great sorrow, saw fit to throw all the blame

on me. In reply to her first letter—which seemed more in sorrow than in anger—I wrote a long letter, expressing my sincere regret, my condolences, that I would have tempered the report had the facts come to my knowledge. That only seemed to add fuel to the flame, and wound up by demanding a public apology. There the matter rests.[42]

With the ever-changing scene along the Rio Grande route to Silverton, Joel Brewster and his sizable family had assumed operation of the Carr's Cabin site developed by the Jennisons. The Brewsters soon expanded operations to incorporate lodging, boarding, storage and packing activities. The post office was reopened there on April 11, 1877. For simplicity's sake—but confusing to later historians—both parties decided to keep the name Jennison's, and the postmistress this time was Lucy Brewster, Joel's forty-two-year-old wife and mother of their eight children. Their place at the east end of Brewster Park was the last regular accommodation point on the trip up the Rio Grande at this time, and it came to incorporate several buildings, both at the old Carr's Cabin site and nearer the trail and the river. Jennisons, as tended by the Brewsters, was primarily astride the road in the middle of the park. After two years, the Brewster clan would move their entire operation to the far western end of Brewster's Park, discontinuing the Jennison post office and developing the short-lived settlement of Timber Hill. On April 25, 1879, Lucy J. Brewster was the postmistress at the newly

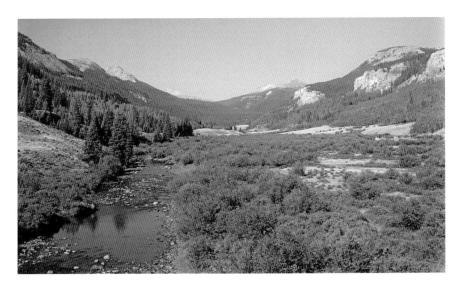

Brewster Park on the Upper Rio Grande. *Author collection.*

established Timber Hill post office until it was discontinued on November 21, 1881. When the rails arrived in Silverton in early 1882, the Brewsters packed up and took their buildings with them. He was a freighter after all, so he simply dismantled his house and barn, loaded the logs onto his freight wagons and established a freighting stop over the pass in the Rico and Ouray area.[43] Today, nothing remains in the narrow valley of the former Jennison/Brewster operations—an early-day example of "leave no trace" camping.

5

MEDICINE WOMAN OF THE UPPER RIO GRANDE

Dr. MaryAnn Wattles Faunce

Dr. Faunce, who nursed Civil War Soldiers, passes
MaryAnn Wattles Faunce was born in Mercer County, Ohio, October 10, 1845. She came of early Plymouth Colony stock. Childhood was spent in Ohio. Her parents were leading abolitionists prominent in the anti-slavery movement. The family later went to Ktheoansas in wagons and joined the movement to keep Kansas a Free State.

During the Civil War she nursed both Union and Southern soldiers in the battle fields and in temporary hospitals. This led to her taking up the study of medicine. After graduating from Oberlin College in Ohio, she took her medical degree in the Women's Medical College of New York. With a few years of advance study in Europe, she returned to the Women's Medical College where she was professor of Anatomy for 17 years.

On July 4, 1882, she was married to Sylvanus C. Faunce and lived in New York City, where her three children were born; Theodore, Eugenia and Hilda. The family later moved to Southwestern Colorado where she has made her home ever since. In 1927 Dr. Faunce and her husband moved to Creede, where she has enjoyed good health and many delightful friendships. On June 3, 1935, she passed peacefully away at 89 years, 7 months and 21 days. She is mourned by her husband, her son and two daughters, four grandchildren, and one great-grandchild.

To the memory of my dear wife and friend—MaryAnn Wattles Faunce

Love is the only bow on life's dark cloud. It is the morning and evening. It shines upon the babe, and it sheds its radiance on the quiet tomb. It is the mother of art, inspirer of poet, patriot, and philosopher. It is the air and the light to tired souls, builder of every home, kindler of every fire on every hearth. It is the first dream of immortality. It fills the world with melody, for music is the voice of love.

Love is the magician, the enchanter that changes worthless things to joy and makes right-royal kings and queens of common clay. It is the perfume of that wonderful flower of the heart, and without that sacred passion we are less than nothing but with it is heaven.

Passing out of this life into another is in the order of Nature, one of the many laws of evolution, and dear Mary, may the journey be all that your heart desires.

Your friend, Sylvanus C. Faunce[44]

MaryAnn Wattles was the baby of Augustus and Susan Wattles, who had four children: Sarah (1837–1910), Theodore (1840–1912), Emma (1842–1929) and MaryAnn (1845–1935). The family moved to Douglas County, Kansas, in 1855 so that Augustus and Susan could continue to work for the abolition of slavery, which they had done since the mid-1830s. The activity is what made them true life partners. They devoted their lives to the education and betterment of African Americans. The Wattles family was active in the underground railroad and women's suffrage, and they served wounded soldiers during the Civil War. Augustus was a devoted Quaker and committed abolitionist. His family patriarch had come to this country in 1620 on the *Mayflower* as a Quaker escaping persecution in Europe, so he was steeped in Quaker tenets and theology. Augustus focused his efforts on the sin of slavery, but he also thought women needed to be empowered to help fight the evils of a materialistic society. Susan, an active suffragette, supported her husband in his abolitionist work. Moving into the heart of the fray in Kansas with adolescent children makes it abundantly clear that they were both committed to their ideals. Theodore and his sisters grew up with those lofty ideals and a sense of empowerment for themselves, women included.[45]

They passed their progressive views about the need to improve society and to expand opportunities for women on to their children, especially to their daughters. For the Wattles, the migration to Kansas became a necessary means for accomplishing gender reform.[46]

Augustus and Susan Wattles, along with Augustus's brother and his wife, John and Esther Wattles, lived in many places throughout Ohio and Indiana and then moved out to Kansas after the passage in May 1854 of the Kansas-Nebraska Act. Likely the most significant event leading to the Civil War, the act created "Bleeding Kansas," the central battleground for the abolitionist movement. The Wattles home was used as a meetinghouse for the secret gatherings with other abolitionists, including John Brown and his raiders. MaryAnn would tell stories later in life of peeping down from the upstairs landing to quietly spy on the meetings—pretty heady stuff for a ten-year-old girl. Another story comes from when the Wattles family lived in Moneka, Kansas, in times of real personal danger to all the family members. The children were instructed to keep their clothes laid out beside their beds, in order to be able to quickly put them on and run to a nearby cave that Augustus had found, enlarged and provisioned. There the family could hide until the danger passed. This early exposure to crisis and conflict imbued MaryAnn with a calm and practical approach to any situation.

The radical abolitionist John Brown was friends with both John and Augustus Wattles, especially Augustus. While the Wattles brothers agreed with Brown's goals, they often disagreed with his methods. Whereas Brown was convinced that slavery would be ended only through violence, Augustus sought to attack it by changing people's minds. In December 1858, however, when Brown needed a place to stay after a Missouri slaveholder was killed during Brown's raid to free eleven slaves, Augustus offered sanctuary at his own home in Moneka, even though the Missouri governor insisted that Brown and the slaves be returned to Missouri.[47]

During his stay with the Wattles family, Brown wrote a letter to the *Lawrence Republican*, comparing his raid into Missouri with the Marais des Cygnes Massacre, in which a raiding party from Missouri had crossed into Kansas and, near a settlement called Trading Post, killed five men suspected of being antislavery supporters and badly injuring five others. Wanting to protect the Wattles family from any retribution that would have followed had the proslavery element known that Augustus had provided sanctuary to him, Brown indicated that he was writing, not from Moneka, but from the more distant town of Trading Post. In the last days before his execution nearly a year later, Brown, in one of his final letters to his wife, referred to the Wattles family in the following words:

Most beloved and never to be forgotten by me. Many and many a time has she [Sarah Wattles], *her father, mother, brothers, sisters, uncle and aunt,*

(like angels of mercy) ministered to the wants of myself and of my poor sons, both in sickness and in health.[48]

Augustus died at the age of sixty-nine in Mound City, Kansas, on December 19, 1876. His wife, Susan, remained active, continuing her correspondence on behalf of the rights of women and seeing many strides in women's equality. She died in Mound City on January 9, 1897, at the age of ninety-four. Although women had been granted the right to vote in municipal elections in Kansas in 1877, full women's suffrage was not granted until 1912, long after Susan was gone.[49]

When the Civil War broke out in 1861, MaryAnn was sixteen years old. She and her mother, Susan, were tireless workers in the local hospitals that treated wounded men from both sides of the fighting. American medicine was primitive, and treatments were harsh and often ineffective. Amputation was the treatment of choice for broken or severely wounded limbs, although a great percentage of these operations resulted in the death of the patient. There was no modern anesthesia, only chloroform or ether. Surgery wasn't sterile, there were no antibiotics and men suffered horribly. MaryAnn "grew up" during the years of the Civil War. She was twenty when it ended, and she had been irrevocably imprinted with the need for better American medical treatments.

After the war, her widowed aunt Ester Wattles (her husband, John Wattles, died suddenly in September 1859) returned to Oberlin, Ohio, where she kept a boardinghouse with her three daughters and niece MaryAnn. The girls were enrolled in Oberlin College, from which they all graduated, MaryAnn obtaining her degree in 1868. Oberlin had been founded by progressive Presbyterian minsters, and its first president had liberal views toward abolitionism and antislavery, which greatly influenced the philosophy of the newly founded college. Only two years after its founding, the school began admitting students of all races, becoming the first college in the nation to do so. The college admitted its first group of female students in 1837, and in 1841, Oberlin was the first to grant bachelor's degrees to women in a coeducational program.[50]

With the loss of so many young men in the Civil War, significantly expanded opportunities for women arose in many areas, including medicine. MaryAnn was determined to become a medical doctor, and in 1869, Susan Wattles took her to meet Dr. Emily Blackwell at the Women's Medical College of the New York Infirmary, where she was accepted. Despite many roadblocks, but with the unfailing support of her family, she graduated from

Woman's Medical College of New York Infirmary graduating class of 1871. Dr. Wattles is second from right in the back row. *Author collection.*

the medical college. (The school had been established by Emily and Susan Blackwell in 1868, with its first graduating class in 1871.) Dr. Wattles gave the valedictory address at the commencement—she was twenty-six years old. However, the toll of completing a four-year course in three years resulted in some health issues. To rest and recover her health, she stayed for a time with her uncle David Ripley, who had financed her education.

After graduation and working at the New York Infirmary, and with the knowledge of the shortcomings of American medicine that she observed during her Civil War experiences, Dr. Wattles wanted to expand her expertise and study in Europe, which had a much more advanced medical system that was more scientific and research based. However, few universities allowed women as students. Fortunately, in 1873, the University of Leipzig started accepting women as "guest students." It was one of the first and one of the few schools that allowed women students for some years.[51]

Dr. Wattles made an effort to learn German while at Oberlin, and with her pluck and courage, she boarded a steamer ship for Leipzig in 1875. She

was able to observe surgery using the Lister method, which utilized carbolic acid as a disinfectant and was significantly successful in preventing surgical infections. Dr. Wattles wrote of this procedure to Dr. Emily Blackwell back in New York and recommended the process highly. American medicine was still in the process of catching up with the rest of the world.

Dr. Wattles also corresponded with friends who were studying in Vienna, taking the few classes that were open to women. She then traveled to Vienna and spent another year studying there before coming home in September 1876. Determined and more than capable, she took a position as instructor of anatomy at the Woman's Medical College of New York and had a small private practice. She was thirty years old and a spinster (by the standards of that time). However, the country was still reeling from the loss of countless men during the Civil War, and the many women who remained single were not ostracized as they might have been just a few years earlier. There was a respectability to being single, having a profession and earning one's own income.[52]

Although being married was not a specific goal in her life, Dr. Wattles did date and entertain male friends. Her friends from Oberlin who now lived and worked in New York, as well as women from the medical college, formed a highly intellectual and progressive group. One of the young men who was part of this gregarious group was an accomplished artist, handsome and debonair—Sylvanus Carroll Faunce, who became a frequent companion. Carroll had a similar family history, as his patriarch had come to this country in 1623 on the ship *Anne*. His family were staunch Quakers and became abolitionists and suffragists. Carroll and Dr. Wattles shared common social and political views. Although he was ten years her junior, love prevailed. On July 4, 1882, they were married. He worked as a textile designer and was well regarded. In 1883, they moved to Brooklyn to be near his work, and Dr. Faunce commuted to Manhattan to work at the Women's Medical College, which she continued to do until 1892. Between them, they made a good income, and he came from money.

The S.C. Faunce family lived in Rochester, New York, and had three children: Theodore Faunce (1883), namesake of his uncle Theodore Wattles; Eugenia (1885); and baby Hilda, who was born in 1887, when Dr. Faunce was forty-two years of age. Trying to be a professional woman with a career, taking care of a house before modern conveniences and raising three children would have been an insurmountable task. Fortunately, the Faunces had money and could hire live-in help, especially women who were down on their luck, divorced or widowed. Even with the domestic help, Dr. Faunce

Theodore and Eugenia Faunce, New York City, 1888. *Author collection.*

felt overwhelmed and asked her widowed mother, Susan Wattles, to come live with them, which she did from 1884 to 1892, when Dr. Faunce retired from her practice and teaching. The family moved in 1893 to a suburb of Boston, Massachusetts, where Carroll's work took him; Susan returned to Mound City, Kansas, where she lived until her death.

In 1891, the Faunces and Susan Wattles went on a family trip to Goshen, Connecticut, to visit relatives. Carroll, in possession of a new camera and

Hilda and Papa Carroll Faunce, New York City, 1888. *Author collection.*

being an artist, took some excellent photographs of the three generations of Wattles women in an arranged setting.

Dr. Faunce's beloved big brother Theodore Weld Wattles served as a first sergeant in the Union army, Company D, Fifth Kansas Cavalry Volunteers

From left to right: Susan Lowe Wattles, Dr. Faunce and Eugenia Faunce, 1891. *Author collection.*

during the Civil War, and was mustered out in April 1866. He worked for the army in Albuquerque for several years and moved to Fort Defiance, New Mexico, in 1875, where he worked at the Navajo Agency, weighing and inspecting wool and other Indian goods. In 1878–79, he moved up to Parrott City, Colorado, where he worked in mining and freighting. He then moved on to Mancos, where he took up farming. In a letter from Christmas 1882 to his sister Dr. Faunce, he thanks her for the nice Christmas card and relates the challenges of getting started in a new location. Apparently, he was living in a small cabin but was building a larger house, possibly with plans in mind for a more permanent residence at a place that he very much liked.

> *I went out to the woods and got a load of posts for my fence. I am keeping two yoke of oxen here to haul fencing with. My partner is keeping the balance over in Alkali Gulch, 8 miles west of Fort Lewis. I was after dark getting home tonight. I stopped in the woods with the boys that are chopping for me. They had a rabbit pot-pie and thereby I lost an hours' time. I have got my house up and the roof on and the stone hauled for the chimney and lumber here for the floor, but I have not got it chinked and daubed yet. It is too cold now; the mud would freeze and crumble out. Don't know what I want with another house, though, this one is good enough, only I didn't joint it up this fall when I came home and you can see through it on all sides. It freezes here nights and would be pretty cold sleeping alone, but the dog gets under the blankets with me. With much love, your happy brother, Theodore.*[53]

Theodore married Malvina Hammond in 1885; they had two children and lived on an irrigated farm in the Mancos Valley of Colorado, where he remained until he died. Coming from a learned family that placed a priority on education, Theodore was happy to help build a school in 1891, which became known as the Wattles School. By 1897, the school enrollment in the area was 247, and other schools had to be constructed. He was a member of the fraternal organization of the Grand Army of the Republic Post (for Union soldiers) in Durango.[54]

Dr. Faunce and Carroll had started purchasing land in Mancos as early as 1889, based on recommendations from Theodore. With Carroll and Dr. Faunce both working, they were reasonably prosperous, and they dreamed of a thrilling life out West. Dr. Faunce had grown up in and loved the western frontier of Kansas, and Carroll was excited with the prospects of becoming a farmer. However, it was many years until they were actually able to move to Mancos. Theodore made arrangements to have their land farmed by

renting it to tenant farmers and produce taken to market. He continued this practice until the arrival of Dr. Faunce and Carroll in August 1899, which was precipitated by the Panic of 1893.

On August 8, 1893, President Grover Cleveland and Congress repealed the Sherman Silver Purchase Act, bringing about a financial crisis. Banks closed their doors, and real estate values plummeted, resulting in the immediate abandonment of many businesses. Even though Carroll had kept his job as a textile designer, he and Dr. Faunce were heavily involved in debates for the political reforms sweeping the country. Carroll, always an irascible and argumentative sort, found himself debating the validity of some potential reform that did not sit well with his employer, resulting in his dismissal in 1898. Although Carroll was able to obtain alternate employment, he knew his time was limited, and he was frustrated. Dr. Faunce was fifty-three years old and yearned for the life out West that they had been planning. As the children were adolescents, she and Carroll decided to pull up stakes and move out to their Colorado ranch.

However, Dr. Faunce also wanted to get her Colorado medical license so that she would be able to continue to practice, which required a year of residency with an established physician. She had to be elsewhere than Mancos because of its lack of any medical practitioner. There was a Wattles family connection with a Dr. McHugh in Fort Collins, and Dr. Faunce decided to move there in August 1898. Additionally, there was a new county hospital in Fort Collins, and she was able to get on with the hospital physicians to complete her in-state residency. Her son, Theodore, was sixteen, Eugenia was fourteen and Hilda was eleven. The children attended Franklin School in Fort Collins starting in the fall of 1898. Carroll planned to continue living and working back East until the year was up and then join the family for the move to Mancos.

Mrs. Faunce and son and two daughters, late of Boston, Massachusetts, are among the recent arrivals in Fort Collins. They are stopping with Mr. and Mrs. Stratton until they can find a suitable house to move into. Mr. Faunce will come here as soon as he can close up his business in the east, and make Fort Collins his home. Having noticed Dr. McHugh's professional card in the Courier, they wrote him inquiring about the climate, church and school advantages and were so well pleased with his reply that they packed up at once and started for this city, so that the son could enter college at the beginning of the college year. They are delighted with Fort Collins and are looking about for property they can purchase.[55]

From left to right: Hilda, Theodore, Dr. Faunce and Eugenia Faunce, 1898, Fort Collins, Colorado. *Author collection.*

After the year-long hiatus, Dr. Faunce had her Colorado medical license, and Carroll joined the family in Fort Collins. The Faunce family then moved to Mancos, Colorado, in the summer of 1899, just across the meandering Mancos River from the Benjamin and Marion Wetherill family of five boys and one daughter. Although the three Faunce children had attended school in Fort Collins, they did not do so in Mancos, as they were all past elementary school, which was all that was available at the time. Dr. Faunce attempted to provide some form of home schooling, but later in life she lamented the fact that none of her children was college educated, while she had been the recipient of so much advanced education. The children were assigned tasks on the farm, and Theodore relished the outdoor life. The Faunce girls, Eugenia and Hilda, were quickly becoming young ladies and had many friends among the neighboring families. In 1905, Hilda, just turned eighteen, eloped with the recently divorced thirty-six-year-old Winslow Wetherill, creating quite the local scandal. They moved to the Pacific Northwest, where they remained for several years, returning to the desert Southwest in 1914. In 1907, Eugenia, through proper channels, married Clayton Wetherill and moved to his homestead in southern Colorado at Hermit Lakes near Creede.

From left to right: Bess Morefield, Eugenia Faunce and Hilda Faunce in Mancos, Colorado, circa 1901. *Author collection.*

Once in Mancos, the Faunces pursued their western dream on a lovely one-thousand-acre farm with good soil and plenty of irrigation water to grow a variety of crops. By this time, Dr. Faunce was fifty-five years old. Though still called upon for women's issues, delivering babies and attending sick children, her informal practice was more limited than it had been back East. However, Dr. Faunce was often called upon for her help. With the assistance of good friend and next-door neighbor Marion Wetherill, she reached out to help nearby Indians with serious health concerns. Dr. Faunce was also active in managing the large farm, assisting with planting and harvest, keeping bees and entertaining. She also enjoyed spending time with her brother Theodore and his family, who lived next door, and she provided medical care for his various ailments.

Mancos Valley, circa 1900. *State Historical Society of Colorado*.

The Faunces depended significantly on the help and support of the Theodore Wattles family. However, Carroll Faunce discovered that farming was not really his forte, and he soon lost most of the family funds. The panic of 1907, resulting from the earthquake in San Francisco in 1906, which drew gold out of the world's major money centers, created a liquidity crunch that sparked a recession starting in June of that year, severely affecting the agricultural community. The Faunces struggled along, but their farming dream was over. They split off parcels of the farm and started selling them in 1909. Carroll attempted some ill-advised investment schemes and contacted their numerous relatives for support, but to no avail. Dr. Faunce was compelled to sell her beloved bees, from which she had obtained a nice income selling honey and honeycombs.

S.C. Faunce and George Mallett this week closed a deal with Robert Burgess & Sons, of Denver, for the four-year old Percheron stallion which the company shipped in here a few days ago, for the consideration of $2,800. This is one of the finest bred animals ever shipped into this part of the state and imported from France to this country about a year ago. The bringing in of this animal will give quite an added impetus to the movement for a better grade of horses in this valley and we hope to see the movement grow and spread.

Mancos Valley: 1,000 acres being sold in small tracts that have raised wheat, oats, barley, fruit, beets, potatoes and peas. Prayers for rain are good, but an irrigation ditch is more reliable—never a failure of water or

Sylvanus Carroll Faunce sketch, circa 1914. *Author collection.*

crops in all of these farms that are irrigated with FREE WATER WITH EARLY PRIORITIES. If you are in search of rich soil, sure water, and a home in a beautiful valley, don't fail to look over this property: C. FAUNCE Mancos Valley Ranch.

For sale—thirty hives of bees, enquire. Mrs. M.W. Faunce.[56]

Dr. Faunce was assisting her brother Theodore with his serious illness and wanted to stay in Mancos to be near him. Upon Theodore's death in 1912, the Faunces called it quits and moved to Denver to allow Carroll to paint landscapes. From there, they moved to Estes Park, where he continued his painting. Dr. Faunce did not practice, but she retained her medical license.

In 1915, destitute and needing money, Carroll returned to New York to the textile business to earn enough money to support Dr. Faunce and himself; he was sixty years old, and she was seventy. They decided that it would be cheaper for him to go alone and live by himself, so Dr. Faunce moved to the Wetherill Fish Hatchery up the river from Creede to stay with her daughter Eugenia, who was married to Clayton Wetherill. Eugenia had two small sons, Gilbert, born in 1909, and Carroll, born in 1911, both having been delivered by Dr. Faunce when she traveled up from Mancos to be with her pregnant daughter. Clayton spent a good deal of time away from the hatchery during the summers, when he went off with his brothers to the Southwest on a variety of exploration trips into the four corners country to

search for prehistoric ruins. It was a blessing for Eugenia to have her mother with her to help with the small children at the remote mountain ranch.

Additionally, Dr. Faunce became an in-home obstetrician to local ranch women, who had her move in with them as their time approached. She would stay with the family until the baby was born. On the remote mountain ranches, there were no phones, and it took a long time to get a message to either Dr. Faunce or the doctor in Creede. It was much appreciated to have such an experienced doctor right in the house. Several multigenerational families in the Upper Rio Grande area have stories about a "woman doctor" delivering their grandmother or grandfather—that would have been Dr. Faunce.

In 1918, Dr. Faunce received a letter from her youngest daughter, Hilda, who was living on the Navajo reservation with her husband, Winslow Wetherill. They were about to embark on a new vocation in farming near Farmington, New Mexico. In the letter, Hilda defended their decision to take on a farming career, writing: "Farming can't stop because it doesn't pay. Though any other business can, and it stands a better chance of paying now than it ever did, Papa failed because he was not a rancher, but not because ranching does not pay." On the San Juan River outside of Farmington, New Mexico, Hilda and Win started the farm they had always wanted.

Hilda and Win farmed for two years, then Win suffered a severe accident. He was kicked in the head by a horse and subsequently became erratic and abusive. Family stories relate that Win would wake Hilda on moonlit nights and force her at the business end of a gun to go out and hoe the fields. Hilda finally enlisted the help of her brother-in-law to escape Win's domination. She moved to California and entered nursing school in 1923. Win filed for divorce in 1928, claiming abandonment, which Hilda did not contest. He lived the remainder of his days near Farmington with the children from his first marriage. Hilda never remarried, but her love for Win and the sadness of their life apart was a burden she carried the rest of her life.

Dr. Faunce also took care of the frequently ill Clayton and helped with the fish hatchery and the raising of the children. Although Clayton lived an active and hard life, he was plagued throughout his days by recurring health problems, referred to at the time as "rheumatism." It was most likely rheumatic heart disease, a cardiac inflammation and scarring triggered by an autoimmune reaction to a streptococcal bacterial infection, which causes inflammation of the connective tissues throughout the body, especially those of the heart, joints, brain or skin. Without antibiotic treatment, which was not available during his lifetime, the infection can recur at any time, causing

a variety of symptoms, commonly joint inflammation—swelling, tenderness, and redness over multiple joints. As is known today, the infection also scars the valves of the heart, forcing it to work harder to pump blood. The scarring of the heart can lead to a serious condition known as rheumatic heart disease, which can eventually lead to heart failure. This is apparently what happened to Clayton.[57]

In the winter of 1919–20, Clayton suffered greatly. However, he wanted to stay and be with Eugenia for the birth of their child. In March 1920, Eugenia had their third child, with the help of her mother, Dr. Faunce. Clayton was at the hatchery for the birth, but shortly after left for Farmington to stay with Win and Hilda. He knew that going down to a lower altitude and warmer climate would help him. Clayton had been there only a couple of weeks when he apparently took a turn for the worse. Hilda sent a telegram to her sister and mother that they needed to come to Farmington to see Clayton. A good neighbor just across the road volunteered to take them immediately to the train in Creede to begin their trip, along with month-old Hilda. Dr. Faunce's son, Theodore Faunce, who had been on one of his frequent visits to his mother and sister, was able to stay with and care for the two older children.

L.S. Officer brought Mrs. Clayton Wetherill and Mrs. Faunce [MaryAnn] down from the Wetherill hatchery Thursday upon receipt of a telegram from Farmington, New Mexico, stating that Clayton Wetherill, who left here about two weeks ago, was seriously ill. They took the evening train.

Clayton Wetherill returned to Creede and home last Monday from Farmington, NM, where he was taken very ill more than a month ago. He is recovering slowly, but is still weak and may be compelled to seek a lower altitude permanently.[58]

A few months later, when the summer had warmed the mountains, Clayton returned and somewhat recovered his health. Then he was off again to participate in some of the desert trips he had planned. However, he was not strong, and on his return to the hatchery in the fall of 1920, he and Eugenia asked for help from her brother Theodore. However, that proved to be another crisis, as Theodore was getting in firewood, always a big fall project, when he had a serious accident.

Mr. Theodore Faunce, brother-in-law of Clayton Wetherill, suffered a broken leg one day last week when the team he was driving after a load of

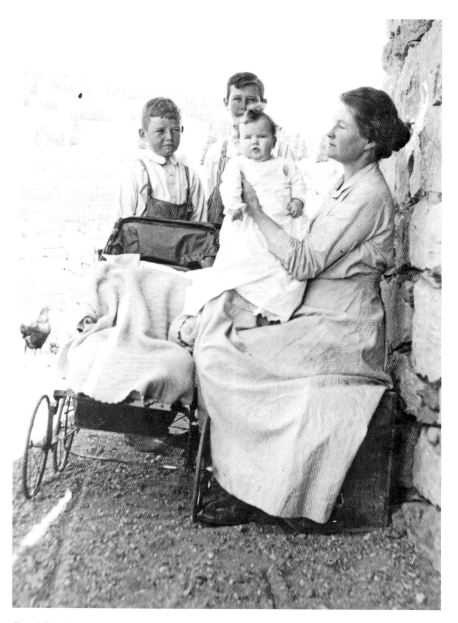

From left to right: Carroll, Gilbert, Hilda Theano and Eugenia Wetherill at Wetherill Fish Hatchery, circa 1920. *Author collection*.

wood became startled at some unknown noise and mixed matters up with their driver. Mr. Faunce was in an isolated canyon alone and after lying unconscious for several hours, managed to reach the wagon, and securing an

axe, made a crutch. This assisted him in recovering one of the horses upon which he rode to the Wetherill home, and the care of his mother.[59]

In the winter of 1920–21, the cold mountain weather again proved too much for Clayton, despite continuous care from Dr. Faunce, and he left for warmer climes right after the holidays.

Mr. Clayton Wetherill left Wednesday for a stay of several months in the southern part of Arizona around Phoenix and Tucson, where he hopes the lower altitude will benefit his health.[60]

Once in the Southwest, Clayton did indeed feel much better, and he was able to take a trip with his brother John's wife, Louisa Wade Wetherill, in February 1921. Louisa, with two of John's brothers, Clayton and Win, and accompanied by Navajo medicine men Wolfkiller and Luka, and a guide, made a trip into Old Mexico to do some intensive studies on the derivation of the Navajo tribe.[61]

When spring had come again to the mountains of Colorado, Clayton returned to be with Eugenia, the three children and Dr. Faunce. According to the *Creede Candle* of April 16, 1921: "County Commissioner Clayton Wetherill returned on Tuesday's train, coming from Arizona, where he has been since January visiting his brother, John Wetherill, at his Navajo Indian trading post outside of Shiprock, New Mexico. Mr. Wetherill's health is still delicate, and he found it advisable to rest at Santa Fe on his way home. Mr. Wetherill left for his hatchery up the river Wednesday morning." Theodore Faunce had spent much of the winter with the family, departing on Clayton's return.

Clayton rallied during the warm summer months, but as fall came on, his health deteriorated, again despite the best care from Dr. Faunce. The altitude and the cold, damp weather were just too much for him. He died in the Hot Springs Hotel on October 21, 1921, at the age of fifty-three, leaving Eugenia a young widow of thirty-six with three small children. Clayton is buried in the Creede cemetery. Eugenia's sister Hilda came to spend time with the family and Dr. Faunce and to attend the funeral. Hilda spent a couple of weeks and then returned to Win.

Clayton Wetherill, who has been very ill for several weeks, has been taken to the hot springs at Wagon Wheel Gap. It is hoped that Mr. Wetherill will be benefitted by the mineral baths there.

Mrs. Win Wetherill departed Monday for her home near Farmington, New Mexico.[62]

Over the years, Dr. Faunce lived at the Wetherill Hatchery near Creede. She worked extensively with Creede's official medical practitioner, a Dr. McKibben, and helped with "women's" cases as needed. During Dr. McKibben's absences from Creede, Dr. Faunce would move into his house and cover his rounds for him. In 1923, she was seventy-eight years old, and she had a driver who hitched the horse and buggy and aided her in going on house calls.

Mrs. Faunce [MaryAnn] *made one of her rare trips to Creede Wednesday, having made the journey down with Mr. and Mrs. Wills in Mrs. Wetherill's brand new sled.*

Dr. Mary Faunce is residing in Creede during the absence of Dr. McKibbin.

Dr. Mary Faunce returned to her home last week after a short stay in Creede. Little Miss Theano Wetherill says she is glad Grandma's back.[63]

Eugenia, with the help of the boys, her mother, her brother Theodore Faunce and her neighbors, continued to run the hatchery for a short time. Dr. Faunce remained with the family. Eugenia sold the hatchery, and with those proceeds and Clayton's life insurance money, she purchased a nearby 360-acre ranch in late 1923. Eugenia was a widow, and the woman who sold her the ranch was also a widow; fortunately, women's rights had come a long way—thanks in no small part to Eugenia's mother, Dr. MaryAnn Wattles Faunce, and grandmother Susan Lowe Wattles.

Eugenia Wetherill has purchased the Robberson Ranch, up the river, consideration not stated.

The final deal was completed this week wherein Mrs. M.J. Robberson received $4,700 in cash from Mrs. Eugenia Wetherill for her ranch up the river.[64]

On the new ranch, there was a homestead cabin, tack shed, barn and corrals, but Eugenia wanted a dude ranch, so she had several other cabins built, and it became known as the Wetherill Guest Ranch, as it remained

Dr. MaryAnn Faunce and granddaughter Hilda Theano Wetherill, Wetherill Fish Hatchery, circa 1920. *Author collection.*

until 1997. Dr. Faunce continued her limited medical practice, helping with the new ranch and raising the children. The nearest doctor was in Creede, about twenty-five miles away, so even at the age of eighty-plus years, she was called upon to attend if a neighbor needed help, and she was happy to do so.

Envelope from Carroll in New York to Dr. Faunce in Creede, in care of Mrs. Clayton Wetherill, 1923. *Author collection.*

Dr. Faunce stayed busy, which helped her cope with the ten-year separation from Carroll. They corresponded regularly, but apparently only once in that time did they see each other, and that was in 1917 at a medical convention in Philadelphia that they both traveled to. All alone in New York, Carroll would write lengthy letters to his children and Dr. Faunce, lamenting the state of the U.S. political system, economic policies and other controversial topics of the day. He was focused on amassing enough money for them to live comfortably and did not want to spend funds traveling. He wanted to work until he was seventy, when he would have some sort of pension. However, the isolation cost him many family opportunities, especially to be with his grandchildren as they were growing.

> *New York City Jan 28, 1923*
> *Dear Mary:*
> *Yours of Jan 13th received, written on your Christmas stationery, I am glad you all had a pleasant and happy Christmas. Sorry I could not be part of it, but it evidently was not so intended. I spent my holiday mending my underclothes. We are having mostly spring weather, it has tried to snow and appear like winter, eight inches of snow a few days ago, snowed all night and half the day. And just as the city force got to work it turned to rain and*

warmed up and it all melted in a few hours. A party from Boston said they had two feet of snow there.

Two months of winter all gone, and it will be only a short time until it is spring and then summer again, how time goes. October 19, 1917, I saw you in Philadelphia; it does not seem so long. In sewing the patch on Gilbert's pants, I hope you did not forget to sew it on after basting. As a kid about the size of [Grandson] Carroll, I had a patch put on the seat of my pants by an old lady who used to visit us periodically and stay several weeks, and make herself useful the while. I put on the pants and went huckle-berrying with several boys and girls of my own age. Traveling around through the bushes tore the patch off; it seemed the old lady only basted it on. I was rear guard all the way home.

Carroll is twelve years old and I have never seen him or Hilda Theano, and Gilbert only once. In two years I will be 70 and you 80 years old. It does not seem possible to me. I must say I do not feel as old as that, and you from your writing and what you say you do around cannot feel your age any more than I.

From the way it looks to me from this point of view; I think the children there have a better show for the future than most of the young people here-abouts. I think big cities are a menace and an abomination to the nation. They harbor too much wealth and are a source of corruption of all kinds, as they always grow at the expense of the county districts. If it was possible to live and prosper in the country, cities would not get so big. A few nights ago, I was awakened by a crash and clatter of glass and loud talk. I got up and looked out of the window, a taxi cab had crashed into a store window on the other side of 8th Avenue, and while I was looking a crowd of two hundred people gathered there in just a few minutes and more were coming when I went back to bed. I do not know where they all came from so quickly, but a lot of people will be seen standing on corners and doorways, etc. I think some of them must sleep standing and leaning against the sides of entrances.

I have not been out all day; I will mail the papers on Monday; I hope you find time to read them. World developments are taking place fast. Love to all, Carroll[65]

Carrol was finally able to leave New York and move to Creede to be with Dr. Faunce at the Wetherill Ranch in 1925. They had their own cabin at the ranch, where they spent the summer months with Eugenia and the children. In 1927, they purchased a home in Creede, as conditions on the remote

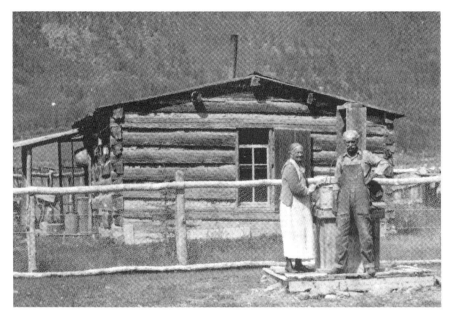

Above: Dr. Faunce and Carroll at their Wetherill ranch cabin, circa 1928. *Author collection.*

Right: Carroll and Dr. Faunce in front of their house in Creede, circa 1930. *Author collection.*

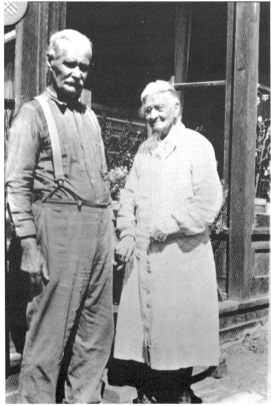

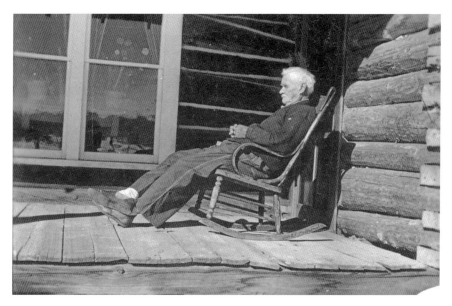

Carroll Faunce on his porch at the Wetherill Ranch, circa 1940. *Author collection.*

ranch were too difficult for elderly folks. Carroll wanted to have access to the amenities that Creede could offer, since it was a small town.

There is a family story about Carroll and Dr. Faunce in their house in Creede, where they lived during the winters. A neighbor stopped by one midmorning and found Dr. Faunce sweeping the floor. The neighbor commented that it was kind of late in the day to be sweeping, which was typically done right after breakfast. Dr. Faunce replied that "Papa doesn't like dust, so I wait until he goes to the train station to get the paper, and then I sweep while he is gone." Carroll continued to be his irascible self, but Dr. Faunce loved him dearly and calmly worked around his quirks.

Dr. Faunce died in June 1935 at the age of ninety. She is buried in the Creede cemetery. Carroll continued to live with Eugenia until his death in December 1949 at the age of ninety-four years and seven months—as contrary as ever. He is buried in the Creede cemetery beside his treasured wife.

OPENING THE CABIN

Or, Al and Ernie

Ifirst met Al "the Packrat" Packer in the fall of 2008, around the first of October, as I recall. He entered my cabin one night—how, I do not know. The doors were locked and the windows closed tightly against the early winter chill. My dad built this cabin in 1936, and it has endured the elements at ten thousand feet elevation on the Upper Rio Grande every winter.

Indeed, Al came in silently enough that none of us heard him. However, he soon forgot his caution when he started rummaging around in the kitchen for some supper. It was late at night, long past bedtime for me and my companions: Rio, Shadow, Bonnie, Nim Nim, Toby and Taffy. Al was making such a racket, knocking things off counters, chewing the cracker box and splashing through the dog's water bowl.

The noise was too much for the dogs, and they made a dash for the kitchen, slipping and scrabbling over the linoleum. Al made a dash for the rafters. Not finding anything in the kitchen, the dogs reluctantly came back to bed. It wasn't long before the noise started all over again, and once more the dogs ran barking wildly into the kitchen, this time with me and a flashlight following closely behind. The beam of the flashlight caught Al perched on a rafter high overhead. This went on all that night and the next.

By the third night I knew some solution had to be found. True, in two weeks I would be leaving for the winter and Al could have his run of the cabin. I could deal with him come the spring, or maybe he would leave of his own accord. But, what to do for the next several nights? The dogs could

Al's winter residence. *Author collection.*

sleep during the day and were ready to chase Al all night, as he was coming in looking for some food. Food! That was it, just feed him!

There was a pretty, old-fashioned ceramic cereal bowl in the cupboard, the kind that used to come in a box of Quaker Oats. It was shallow, cream colored with blue flowers around the edge. I used this bowl and put out some dry oatmeal for Al. He could spend the night taking the oatmeal to his nest and not run around looking for food. This plan had partial success, but Al must have lived nearby, because he emptied the bowl four times before midnight. Now what?

As I wearily trudged out to the kitchen yet again, I spied a bottle of vodka tucked away behind some boxes on the counter. Well, why not? It works for people. The recipe was a cup and a half of oats, and a half cup of vodka, gently stirred until the oats were well coated. Placing Al's supper in a handy place, I returned to bed and didn't wake until the morning sun was bright in my eyes. It worked! Now, if I only had enough vodka for the next several nights.

Really, a confession is in order. I secretly hoped that in his inebriated state Al would fall off of the rafters and plummet to the floor, whereupon the dachshunds would, you know, do what dachshunds do....Well, unfortunately

that didn't happen, so I had to continue to make Al's special supper every night. It did require a trip to town to resupply oatmeal and vodka before I moved out for the winter.

Springtime came, and I was up with the family to open my cabin. We arrived around noon, and as I walked into the cabin I could hardly believe my eyes. Al had been very busy indeed, missing his special suppers, I guess. Silverware strewn about, boxes and cartons of various types and sizes torn up and scattered around, containers of spices knocked off the spice rack, books and magazines on the floor—just an incredible mess. However, the mess was not the priority. Everyone had specific jobs to do, including turning the propane on for heat, lighting the refrigerator and turning on the water. My son Bill was outside turning on the water, and my job was to close the faucets in the kitchen and bathroom, wait for the water to start flowing and check for leaks. While in the bathroom, I noticed that the tank top to the "necessary" was laid across the bowl of said fixture. As I picked it up to place it back on top of the tank, I glanced in the bowl, and—wait, was there a roll of toilet paper down there? Maybe, but it didn't look quite right. Toilet paper rarely has a black tip on its tail.

Retrieving the flashlight from the bedroom—thankfully, the batteries had survived the winter and provided a good beam of light—I took it and went to get a good look at the bowl situation. As I turned the beam into the bowl, I saw Ernie the Ermine, mostly covered with pink antifreeze. I had met Ernie late in the summer of 2008, but then, of course, as ermine are in warm weather, he had been in his alias attire as a brown Wes the Weasel. Wes could be seen over the summer looking for food in the woodpile, hunting along the pole fence or sunning himself on the picnic table. As summer turned to fall, Wes began his color change to white, becoming Ernie the Ermine. (Ermines are weasels in winter white, camouflaged so they're lost in the snow, but they still retain the black tail-tip of their summer coat.) I think of all the fancy ladies of the past, and maybe some today, who were so proud of their ermine wraps—and all they really had was weasel fur. Oh well, back to my story.

In the kitchen, I found a plastic trash sack, which I put over my hand. I returned to the bathroom and freed Ernie from his antifreeze grave. However, there seemed to be something else in the pink depths. What now? I closed the plastic sack, which now contained Ernie, and placed it on the floor. I returned to the kitchen for another sack and went back to the bathroom. I aimed my light into the bowl once again. Floating in the pink antifreeze was Al "the Packrat" Packer. "Oh, Al," I said, "I had left you with a nice big bowl of oatmeal and vodka when I departed for the winter. I hope

Al and Ernie's final resting place. *Author collection.*

you liked it." I used the second sack over my hand to free Al, and I placed him in the first sack with Ernie.

By now, the propane was on, and the pilot lights of the refrigerator, stove, hot water heater and space heater were all lit. The water was flowing, so I flushed and looked for possible water leaks. None appeared. It was a successful cabin opening.

That evening, we took the two warriors—one who battled for his life and the other who battled for his food—down to the old cabin on the hill in back of the barn and buried them together. We surmised that after many chases around the cabin (hence the mess), Al had dived into the toilet bowl in an attempt to elude Ernie, who promptly followed him in, where they both met their demise. It was a sad thing, but, you know, I have not seen a single mouse in the cabin yet this summer. Ernie must have had a fearsome reputation.

THOSE WHO WERE THERE BEFORE

The Rio Grande Reservoir Dam

I n what is now the bottom of the Rio Grande Reservoir, along the upper reaches of the Rio Grande River, the streambed meandered through a deep valley between towering peaks, creating lush mountain pastures. Early settlers to the area in the mid-1800s established ranches to take advantage of the rich grass for their livestock. As silver and gold were found in Beartown and Silverton, the demands of the mining fever created a need for animal fodder at the mines. The area ranches took advantage of the rich grass along the river to make hay for transport to the mines with the help of the Del Norte–Silverton stage road that passed through.

Two major hay ranches in the area included Jackson's, near the southern end of this valley, and Kingman's, which was on the northwest end, near the Ute Creek confluence with the Rio Grande. The ranches had been bucolic, but with the discovery of gold and silver in the 1870s, the press of men, materials and animals along the stage road created something else entirely. For nearly a decade, the stage road was a major access route by which many tons of freight were hauled into the central San Juan Mountains and ore was hauled out. This route through the Continental Divide had thousands of pioneers traveling through during the era, beginning with Baker's Park settlement in 1873. Traffic tapered off in the early 1880s. The stage road's peak transportation years were 1875–82, after which it was nearly abandoned following the arrival of the Denver & Rio Grande Railroad in Durango in 1881 and in Silverton in 1882. The impact on the area's residents was significant. Many just packed up and left the area,

Looking upriver from the Rio Grande dam site, before construction. *Courtesy of the San Luis Valley Irrigation District.*

Remains of Kingman ranch at the confluence of Ute Creek and the Rio Grande, circa 1916. *Courtesy of the San Luis Valley Irrigation District.*

while a few attempted to hang on to their former lifestyle. Those that chose to stay were caught up in the development and construction of the Rio Grande Reservoir in the early 1900s.[66]

H.C. Conn was killed by a bear at the head of Ute Creek Wednesday morning. He was prospecting with F.M. McAdams and M.L. Barker. In the morning, he went out prospecting, saw the bear, a female with two cubs, and returned to camp for a Winchester. His partners heard him fire three shots then yell for help; they rushed to his assistance but when they got to him the bear had done its work and got away. Conn came to them horribly mangled but conscious and able to tell them what had happened. He had shot at the she and hit a cub; then the bear attacked him and he took up a tree but was caught by bruin climbing after him. The flesh was torn from his thigh, scalp and face, both eyes torn out and he was disemboweled. In this horrible condition the unfortunate man lived to be taken to the Kingman's hay ranch, at the mouth of Ute Creek, where he died at 1 o'clock that afternoon. His partners brought the remains to this point yesterday afternoon, and Coroner Mulligan took charge of them. Conn was a miner well known in the camp, having worked in the New York and Chance previous to going out to the Bear Creek country. He has a father living in Blanco, Texas.

William Kingman and Foster Ruckman came over Stony Pass on Wednesday from their opal mine. Judging from the specimens they brought over, they have the finest opal mine on this continent.

Creede was again saddened Thursday evening on learning of the sudden death of Bessie Coombs, the thirteen-year-old daughter of Mrs. William Spangler. Death occurred at the Jackson Ranch near the head of the Rio Grande River where Bessie had gone for a few weeks visit with Ed Jackson's family and on Thursday afternoon was taken with hemorrhages and death claiming her despite all that could be done. The departed child has been in ill health since a year ago when she suffered a most severe attack of pneumonia and all last winter from rheumatism, and was allowed to go to Mr. Jackson's ranch in the hopes it would be beneficial to her health.

Dick Neville…has made his camp at Kingman's Ranch and thinks he is onto something good in that locality. We have argued from the first that the

Prospecting tunnel (*left*) downstream of the present-day dam. *Courtesy of the San Luis Valley Irrigation District.*

inflow of prospectors would lead to the opening of another camp between here and Bear Creek and we are ready to bet on Neville doing it.[67]

In 1891, Susan Ingle McLeod Archer Jackson Tice came to Creede as a widow with several small children to be with her brother Ira R. McLeod. Susan, a mother of one child by Josiah Archer and then six children by Daniel Jackson, who both met untimely deaths, married a third time, to Jonah Tice. She quickly divorced Tice and resumed using the name Jackson. Ira McLeod, a successful businessman in Creede, offered to build Susan a hotel to run. By the early 1900s, Susan, widow and entrepreneur, had hotels in Creede, Beartown, Bachelor and Spar City and a hay ranch on the upper Rio Grande.

After the turn of the century, the construction of the Rio Grande Reservoir Dam was being planned, and the local residents were aware that their time along the river was limited. Susan's homestead ranch was very near what was to become the Rio Grande Reservoir Dam. Susan

sold her ranch to Absalom V. Tabor (unrelated to Horace), who then sold the property to the Farmer's Union Irrigation Company. The sale of her homesteaded land made her eligible to homestead again, which she did farther up (northwest) along the river. She had two of her boys, Ed and George Jackson, file claims nearby her new ranch, and she also wrote her other son, Otis Archer, to come out from Missouri and file a claim. All of these sites were to be affected by the eventual flooding of the lake created by the dam and were thus subject to further relocation.

> *Otis Archer, a brother of Mrs. F.W. Hubbard arrived Friday from Rockville, MO, and on Monday filed on land above Creede.*

> *Mrs. F.W. Hubbard has returned from a visit to her home near Creede. Otis Archer, her brother, accompanied her as far as Del Norte on his way home to Missouri.*

> *D. Miles, Frank Sylvester, and S.J. Schoonover went to the site of the big reservoir above Creede the other day on behalf of the Farmer's Union Irrigation Company, and settled with the squatters at that place for $4,094. This was a very fair and equitable settlement and was made necessary in order that this land and stone may be utilized in building the dam.*[68]

This payment settled the unpatented claims for Ed and George Jackson and Otis Archer, but not for Susan. When the second homestead was required to be moved, she traded her land there for the old stage stop farther up the river at Lost Trail Station. At Susan's death in 1912, her son George Jackson inherited her property and completed the homesteading process. He then received a patent from the U.S. president's office in 1918 for the Lost Trail Station site.

8

THAT DAM(N) RESERVOIR ROAD

Originally Ute Indian country, the Upper Rio Grande area was transformed with the discovery of gold (and silver) in Silverton, Colorado, in 1871. Government troops were dispatched to keep miners out until the treaty could be renegotiated to reduce the size of the reservation. After ratification of the Bernot Treaty in 1874, the rush to the San Juans began. With no roads in the area, the transportation of foodstuffs, mine supplies and mail to the area was difficult, as was shipping ore and bullion out along the treacherous trails, at a cost of forty dollars per ton. Pack animals carried the materials to and from the nearest freight station, which was Lost Trail Station, near the confluence of Lost Trail Creek and Rio Grande River.

Forsyth and Miner, we understand, have the contract for packing the ore from the mine to Barber's [now Lost Trail Station] ranch.

The Stony Pass Wagon Toll Road Company has filed articles of incorporation to construct a toll road from the mouth of Stony gulch, in San Juan County, to the Rio Grande in Hinsdale County.[69]

In 1879, the wagon road was completed from Antelope Park following the Rio Grande River past Lost Trail Station, Timber Hill and Grassy Hill over Stony Pass and down into Howardsville and Silverton (known today as Forest Service Road 520). With the arrival of the railroad into Silverton in

1882, the wagon road, never in great condition, fell rapidly into disrepair. The legacy of maintaining this beautiful, but wild, road remains a challenge to the county commissioners to this day.

> *B. O'Driscoll interviewed the county commissioners on Monday in regard to having the road over Stony Pass fixed early in the spring so that a stage line could be put on to Creede. The amount of money required to put the road in shape cannot be determined at present, and estimates made by various people run all the way from $100 to $1,000. The commissioners promised to inquire into the matter as soon as the snow is off. If the road can be fixed for from $300–$400 they will in all probability have the necessary work done.*
>
> *The work of putting the Creede-Silverton road in good shape has been finished in much shorter time than was estimated at first.*[70]

As the years passed, the road was maintained in passable, if not good, condition. However, with the completion of the Rio Grande Reservoir in 1912, the section of old stage road that followed the river along what is now the bottom of the reservoir was destroyed by water. Locals and travelers established a rough and dangerous trail in the rocks above the dam, but not one that could accommodate a wagon. There was no alternate path around the reservoir. Although there was a very sparse population in the area at that time (as today), again the county commissioners had to step up and protect the road.

> *George M. Corlett and Frank Sylvester of Monte Vista arrived in Lake City on the late train this morning. They are here as representatives of the SLV Reservoir and Irrigation Company to meet with the commissioners of the county and try to come up with some agreement as to the building of the highway to replace the one destroyed by their company's reservoir. We understand that their proposition to the county is that their company will put up a sum of money equal to that given to the county by the state for road purposes, which amounts to $4,200, and the county build the road around the reservoir. These representatives are going on the supposition that the county is obliged to put up money for that apportioned to us by the state. Hinsdale County will get this money without putting up dollar for dollar. No, gentlemen, when your company's reservoir, on which you pay no taxes, destroyed our road, you agreed to build another one. It is up to you to make good, regardless of everything else.*

The Lake City Times recently printed an article to the effect that the Farmer's Union reservoir people wanted Hinsdale County to re-build the road the [the reservoir people] *destroyed because of the erecting of their dam, out of Hinsdale's apportionment of the state highway fund. As the destroyed road was the main highway between the Valley towns, Creede and Silverton, and as, furthermore, the law provides that where the flooding of land destroys a county road the owners of the water shall replace the destroyed road above the highest water mark, this strikes me as being the limit of nerve. It is about on a par with their high-handed action in calmly and unlawfully appropriating all of the water in the Rio Grande. Some of these irrigationists have the most colossal gall imaginable.*

The Farmer's Union people should be compelled to replace, at once, the road that they have destroyed by damming the Rio Grande. It is up to the county commissioners of Hinsdale County to see that the people living up the river and using the river road into the Lost Trail country are treated with justice. No makeshifts should be accepted.

SERIOUS ACCIDENT, Traveler Loses Fine Animal Near Farmer's Union Reservoir
Mr. J.S. McClusky of Ouray lost a fine mare last Sunday on the road near the Farmer's Union reservoir. Mr. McClusky was riding from Ouray to Platoro, and in trying to get around the reservoir where the company has covered the road up in constructing the dam, he came to a place where he could go no further and in trying to turn his horse around on the narrow trail, it fell over the cliff and was killed. Mr. McClusky climbed down the hill and stripped his saddle and other possessions from the animal and then walked to Creede, a distance of thirty miles.

The Farmer's Union people have ruined the road to Silverton and the up-river county in the vicinity of the reservoir, and should be compelled to build a passable road at once, before someone loses their life trying to get around the reservoir.[71]

After protracted wrangling between the Farmer's Union organization and Hinsdale County, the Hinsdale County commissioners eventually filed a lawsuit to force what is now the San Luis Valley Irrigation District to reconstruct the road. The road reconstruction was started in 1914 and was completed in 1915. The lawsuit closed in 1916.

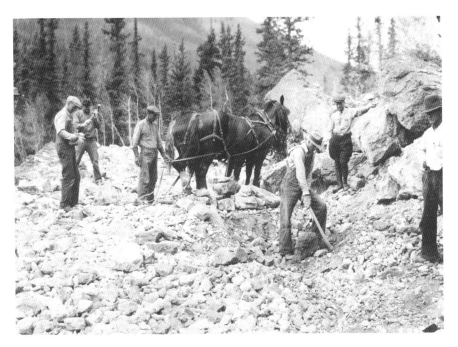

Building the Rio Grande Reservoir Road, circa 1914. *Courtesy of the Creede Historical Society.*

John Britton returned yesterday from a trip to the Farmer's Union Reservoir where he had taken the directors of the San Luis Valley Irrigation District, who met Forest Supervisor Sweitzer and a government engineer from Denver, and together they inspected the new road built around the reservoir to replace the one destroyed by the building of the reservoir. The road was found to be in good shape and with the building of a few additional turn-outs, the government engineer stated that the road would be accepted.[72]

The road was placed above the high-water mark and carved along and through the cliffs on the north side of the reservoir. Some sections of the road were simple earthwork, but along the cliff rock they had to be drilled and blasted out to create a roadbed. A lonely sentinel stands as testament to that effort; a single drill-steel remains embedded in the rock, after being driven partially in when the boss said "far enough." The agreement was to make a one-lane road, but with turnouts for two vehicles to pass each other at twenty-four places along the road.

And the story doesn't end there. Although known as Forest Service Road 520, it is maintained by Hinsdale County, presenting an ongoing problem

Reconstructed road around Rio Grande Reservoir, snaking along just above the high-water mark, circa 1915. *Courtesy of the San Luis Valley Irrigation District.*

Drillling steel in rock along the cliffs from 1914, photograph taken in 2014. *Author collection.*

for road and bridge supervisor Robert Hurd. Fortunately, the 2008 authorization of the Secure Rural Schools Act, Title II, allowed funds to be used for road repairs. Yet again, the Hinsdale and Mineral County Commissioners stepped up and agreed to allocate their portion of funds to the improvement of the Rio Grande Reservoir road. A significant amount of work was done over the next few years, but it will never be a highway. In the words of Robert Hurd, "We don't want that road to be too good; otherwise we'll be fishing tourists out of the reservoir."

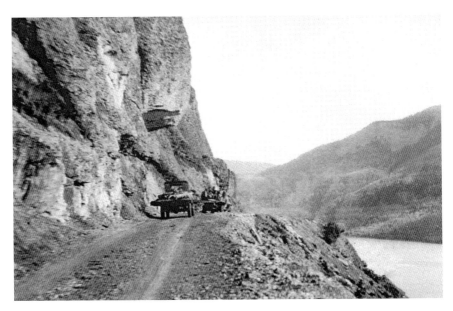

Forest Service "Highway" along Farmer's Union Reservoir, Creede, Colorado, circa 1916. *Author collection*.

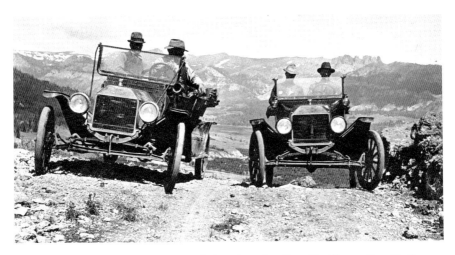

Part of documentary evidence for completion of road, pullout No. 21, near Lost Trail Creek, circa 1916. *Courtesy of the San Luis Valley Irrigation District*.

So, if you are driving that road, please remember it is really a single-lane road, with wider areas for turnouts to allow passing. And if you do stop to allow someone else to pass, please do so at a wide spot in the road!

9

PIONEER FISH CULTURISTS OF THE UPPER RIO GRANDE

In the early 1900s, the Upper Rio Grande fisheries produced more than sixty tons of fish per year. This was a time in the country that saw a large influx of immigrants, with none of the livestock feedlots and farms for production of meat to feed the growing population. Therefore, many people turned to fish as a cheap protein source, driving the establishment of commercial fisheries as a quick and (relatively) easy way to meet the demand.

In 1903, Colorado State Game and Fish outlawed nonlicensed hunters and fisheries in an effort to establish control of wildlife and the fish markets. In 1904, the State of Colorado provided funds to establish private commercial fisheries to produce eyed eggs, raise fry for sale and produce dressed fish for commercial markets. Shortly, there were thirty-nine licensed commercial fisheries, and the Upper Rio Grande became one of the major commercial areas in Colorado for the production of dressed fish and fish eggs.[73]

Fisheries were not completely new to the area. As early as 1866, an entrepreneur named Gordon Land established commercial fisheries in Conejos County in the southern part of the San Luis Valley. He later served as Colorado fish commissioner in 1889. On the Pine River, outside of Durango, the Patrick brothers established native rainbow trout hatcheries in 1885. Shortly thereafter, in 1888, the Durango Rod and Gun Club seined Colorado River cutthroat trout and packed them on horses and mules to Emerald Lake on the Pine River. By 1895, W.T. Kirkpatrick hatcheries in Durango provided cutthroat trout for stocking public waters throughout

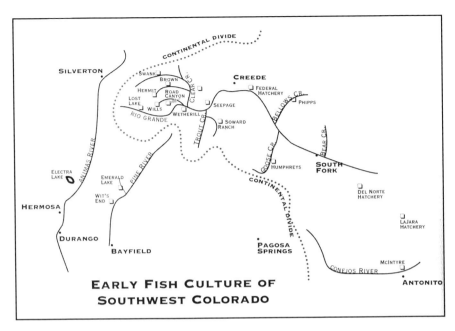

Locations of early fish culture of southwest Colorado. Crusaders for Wildlife, *Glen A. Hinshaw*.

Colorado. At the turn of the century, economic stability created a need for both recreational and production fishing.[74]

The development of commercial fisheries on the Upper Rio Grande was started by an intrepid soul who married into the Wetherill family of Mancos, Colorado. In 1885, Charlie C. Mason married Anna Wetherill and lived and worked alongside the five Wetherill brothers, exploring southwestern antiquities. Several of the Wetherill brothers established trading posts on the Navajo reservation to augment their explorations, but Charlie had different ideas. The Patrick brothers on the Pine River were also part-time colleagues in conducting archaeological explorations, and they told Charlie wondrous tales of the business of raising fish. As Charlie thought about opting for a new occupation, maybe with less time spent in the heat of the southwestern desert, Anna's uncle Justus Tompkins said he thought he knew of the perfect place for a fishery in the mountains. Justus had been with the Hayden Survey and traveled all through the Upper Rio Grande, so he knew the area well. The site proposed was in South Clear Creek Canyon, where there were several small ponds already in existence, and a clear mountain stream with fresh water.

In 1896, Charlie Mason homesteaded and also purchased land on South Clear Creek, where he and a brother-in-law, Clayton Wetherill, built and

From left to right: Al, Win, Richard, Clayton and John Wetherill, circa 1893. *Courtesy of Jim Shaffner.*

raised dams to increase the size of the lakes for raising fish, which he named Hermit Lakes. Charlie Mason obtained the first patented homestead claim for the sole purpose of raising trout for market. Homestead claims were often obtained for mining, timber and farming/ranching, but this was the first claim granted for a commercial fishery. Charlie also obtained the first license in the state of Colorado for raising trout for commercial sale; he kept

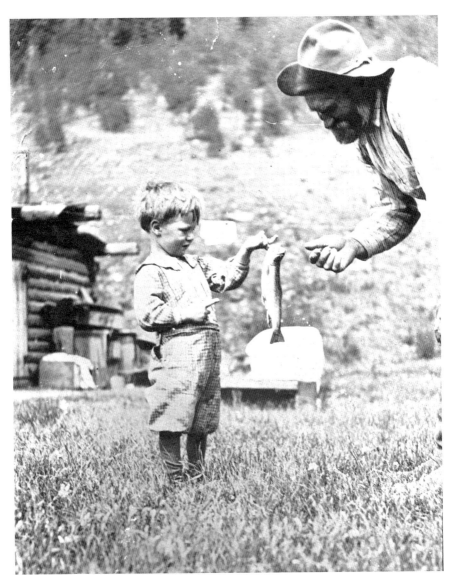

Charlie Mason, fish and boy at Hermit Lakes, circa 1910. *Author collection.*

that No. 1 license until he left the business. Why Hermit Lakes for a name? Charlie said he lived like a "hermit" for the summer months when he was working to develop the fishery, leaving during the winters to return home to Mancos and his family. This lasted a couple of years before Charlie had a cabin built and moved his family to Hermit Lakes in 1899.

Because of his continued relationship with the Patrick brothers, just over Weminuche Pass down on the Pine River, Charlie rode to their hatchery at Emerald Lake and packed cutthroat trout to stock his new fishery. However, the cutthroats did not like the shallow lakes and relatively slow-moving water, and they did not thrive. In 1901, Charlie imported 100,000 Eastern Brook trout eggs from Plymouth, Massachusetts, and they flourished. In fact, the fish did so well that the next year he imported 200,000 eggs, and his hatchery became the source of Brook trout in the Upper Rio Grande. Of course, Brook "trout" are not really a trout, they are a char. However, according to Mr. Webster's dictionary, a trout is defined as "any of various salmonid food and game fishes of the genera Oncorhynchus, Salmo, and Salvelinus, having a streamlined, speckled body and usually inhabiting freshwater streams or lakes. These genera also include the salmons and the chars." So, it's close enough.

Hermit Lakes became a source of eyed eggs, "eggs in which embryos have reached an advanced developmental stage, and fully pigmented eyes can easily be seen."[75] In addition to eyed eggs, which were used for stocking other fisheries, Hermit also produced fry for stocking other lakes and commercial dressed fish. The work was hard. Winters were spent cutting and storing ice in an icehouse for use during the summer, hatching eggs and getting ready for the coming season. Each night during the summer season, gill nets were set, and each morning, the nets were hauled in. The fish were cleaned, packed in ice and then loaded onto wagons. Wagons would arrive in Creede just before the afternoon train left; and the front-range markets of Pueblo, Colorado Springs and Denver were regularly supplied with fresh trout. All of the fish work was conducted in addition to the numerous daily chores of rustic mountain life.

There were no fish on North Clear Creek above the falls, nor in most high-mountain lakes in the San Juans (Ute, Rock, Flint, Vallecito, Highland Mary, etc.).[76] Around 1910, as interest in recreational fishing was growing, Charlie and Clayton saw an opportunity for stocking fish in these lakes, and they packed Brookies to the remote mountain lakes. As the recreational fishing industry grew, Hermit Lakes became a tourist destination. Charlie would meet tourists at the train in Creede and take them up to Hermit Lakes, where they would enjoy a week or so of incredible fishing. Upon their return home to Texas or Oklahoma, the fishing stories grew—as fishing stories are wont to do—and the Upper Rio Grande became a byword for the ultimate fishing experience.

Clayton had been working and living with Charlie Mason at the Hermit Lakes homestead. In May 1907, Clayton married longtime neighbor

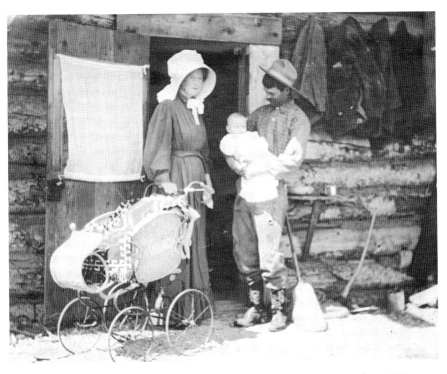

At the Grouse Creek Homestead are, from left to right, Eugenia, Baby Gilbert and Clayton Wetherill, circa 1909. *Author collection.*

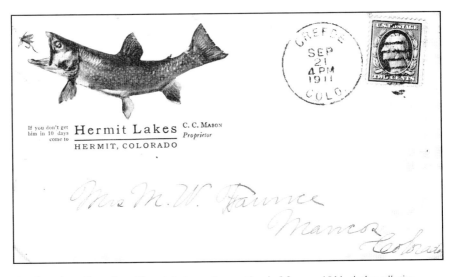

Envelope from Eugenia at Hermit Lakes to her mother in Mancos, 1911. *Author collection.*

Eugenia Faunce in Mancos, Colorado, where they both had grown up, living just across the meandering Mancos River from each other. They moved to Hermit Lakes and lived for a short time with Charlie and Anna and their family. The first order of business was to build their own cabin, which Clayton and Charlie worked on over that first summer. The new cabin was on Grouse Creek, in a small tributary canyon near Hermit Lakes on which Clayton had homesteaded 160 acres. As Eugenia wrote in a letter to her mother, Dr. MaryAnn Wattles Faunce, "I like it here much better than up at the Masons', it is always such confusion up there, and we didn't have a room of our own." Clayton and Eugenia shortly started a family, and baby Gilbert was born in early 1908. As with many small settlements in remote areas, Hermit Lakes in Hermit, Colorado, also served as an official post office.

Anna and Clayton's mother, Marion Wetherill, widowed in 1898, also moved from Mancos to Hermit Lakes to live with the family. She homesteaded 160 acres next to Charlie's about 1906. Until her death in 1923, Marion lived primarily with the Masons, although she did some traveling to see her other three children living in various locations in New Mexico. All of these homestead claims significantly increased the size of the Hermit Lakes holdings.

Shortly after Charlie got his operation at Hermit Lakes going, a neighbor moved in down the canyon and started another fishery. Earl Brown homesteaded and purchased the lakes in 1901 and started a dressed-fish business. It was originally called Troutvale and later renamed Brown's Lakes. Earl married Alice, one of Charlie's daughters, and they raised exclusively Brook trout. Brown's Lakes was eventually sold to the state of Colorado and is now maintained as public fishing lakes.

Another neighbor moved into a canyon over to the west. In 1909, Frank Swank homesteaded a series of natural lakes that he called Castle Lakes. Frank worked with neighbor Charlie Mason to stock Brook trout, which were seined for the markets in Lake City and beyond. Castle Lakes also became a significant source of eyed eggs that were supplied to other hatcheries. As late as 1933, over one million eggs were sold to the Creede hatchery and over two million to the State of Colorado for front-range and eastern Colorado hatcheries.[77] In the 1920s, along with so many other fishing operations, Castle Lakes was converted into a private, nonprofit fishing club; the name was changed to Pearl Lakes. The eight lakes and numerous streams support a club of about eighty members, with full-time caretakers.

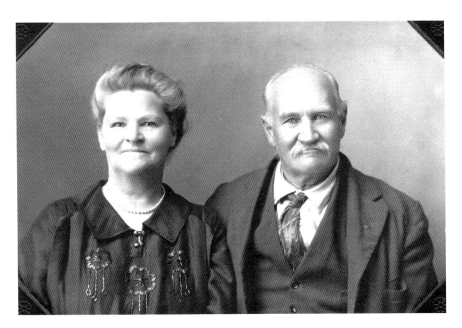

Anna and Charlie Mason, circa 1930. *Author collection.*

By 1920, the front-range market peaked, for many reasons, not the least being the establishment of fisheries there, likely stocked with eggs and fry from the Upper Rio Grande. In addition, the high altitude and grueling work took their toll—especially on Anna. Winters were severe, and the snow was deep. Roads for automobile travel usually closed sometime in November and did not reopen until May; trips to Creede or Lake City were made by team and sled. Charlie and Anna decided to move to the warmer climes of the coast of Washington State for their retirement years; Anna's mother, Marion Wetherill, moved with them. Anna's daughter Marion (Mason Sickles) took over when Charlie retired. She eventually dropped the dressed-fish operation and converted the business into the Hermit Lakes private sportsman's club, which it remains today, encompassing about eight hundred acres and several lakes, with full-time caretakers and numerous private cabins.

Although married, Clayton still left the hatchery and participated in archaeological trips throughout the Southwest with his brothers and guided fishing expeditions. He also packed fish with Charlie. Clayton and Genia Wetherill lived in the little cabin on Grouse Creek for a short time, but when their first child, Gilbert, arrived, the tiny cabin became too small for the burgeoning family. Clayton loved the fish business, so he moved over to the next canyon south and established the Wetherill/San Juan fish hatchery

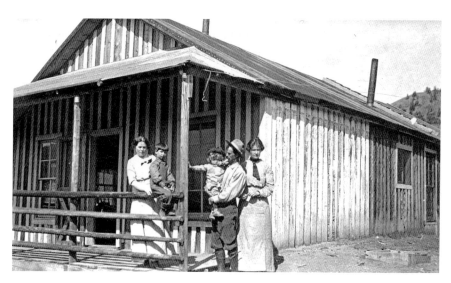

At the Wetherill/San Juan hatchery are, from left to right, Hilda with Gilbert, Clayton with Carroll, and Genia Wetherill, circa 1913. *Author collection.*

at the confluence of the old stage road to Silverton and the road to Lake City. As Eugenia wrote to her mother in late 1908, "Clayt took a load of things down today; we are going to live in one room of Officer's [neighbors across the road] house till the new one is made." At the hatchery, they lived upstairs and had a stone basement with a small creek running through it for eyeing and hatching eggs—Brookies, of course. They also hatched two more children: Carroll Clayton in 1911 and Hilda Theano in 1920. Clayton served as a Mineral County justice of the peace in 1913 and was a Mineral County commissioner in 1920–21. Clayton had lifelong health problems related to having rheumatic fever as a child, and he died in 1921 at the age of fifty-three, leaving Genia a young widow with three children.

True to the start of his life above a fish hatchery, Carroll Wetherill spent his life as a mountain man, guide and fish culturist. Carroll married Ina Wills and had one daughter, Carol Ann Wetherill. Purchasing Lost Trail Station in 1936, he developed a small fish hatchery on the ranch, collecting cutthroat eggs from nearby Lost Lakes. His grandson Bill tells stories of going with his grandfather to collect eggs in the early spring, when the cutthroat spawn. In the high-altitude lakes, spring is slow in coming, so there is still snow and ice over the lake. They would chop a hole in the ice and feed in a net to stop the fish from going down the outlet, where they could be caught. Grandpa Carroll would stand in the freezing water, grabbing

fish with his bare hands and stripping the eggs into a large washtub, once in a while taking a male and squirting in some semen to fertilize the eggs. Bill would soon be frozen and leave to stand by the fire, but Carroll seemed to be oblivious to the cold and worked with ice frozen on his arms. Even after the altitude took a toll on his health, Carroll developed another fish hatchery near Saguache, which after his death was purchased by the state and incorporated into the Russell Lakes complex. Carroll's final heart attack happened while he was operating his bulldozer and digging another pond for his new hatchery. Carroll died of heart failure in 1983 and is buried in the Creede cemetery next to his parents.

During his many years as a mountain man, and following in the footsteps of his father and his uncle Charlie, Carroll packed countless fish into the high-mountain lakes for the state of Colorado in aerated transport cans tied on pack animals. Carroll packed many fish during the years following World War II and into the early 1960s, when the state started planting fish by air.

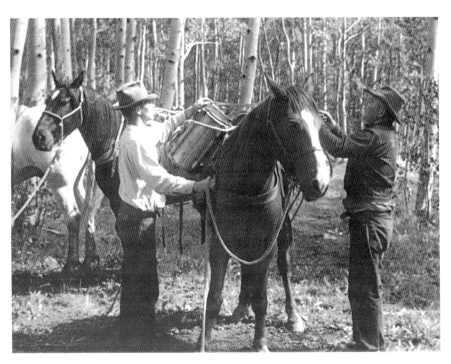

Carroll Wetherill, in dark shirt, and hired man Jake Mallott packing cans containing fish fry for delivery to high-mountain lakes in the San Juans, circa 1947. *Author collection.*

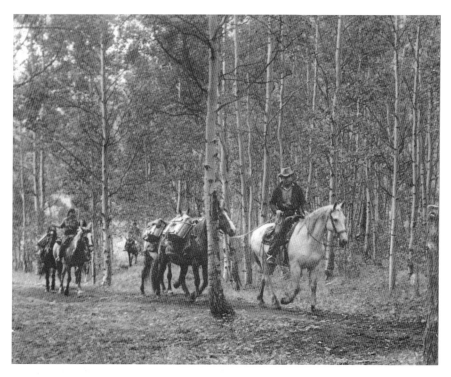

Carroll Wetherill and daughter Carol Ann leading a string of horses packed with fish transport cans. *Author collection.*

Carroll's pack mules with aerated fish cans ready to head up the trail. *Author collection.*

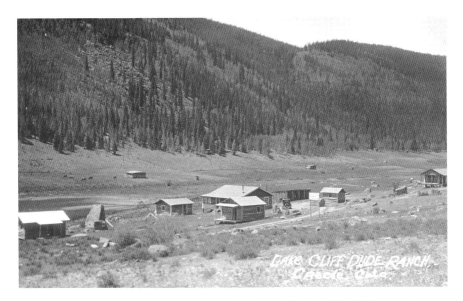

Lake Cliff Dude Ranch, now Wilderness Youth Camp, in Crooked Creek Canyon, circa 1930. *Author collection.*

In 1912, Ina's brothers Frank and Shirley Wills homesteaded and developed the Crooked Creek Canyon lakes into the S Lazy U Fishing Club, as well as the Lake Cliff Dude Ranch, now known as the Wilderness Christian youth camp. Fishing operations at the S Lazy U involved harvesting by fishermen and did not include dressed fish for market. Additionally, there was a small hatchery from which were sold millions of fry to area resort owners to stock their lakes. In 1973, the S Lazy U was converted into a private, nonprofit fishing club on eighty acres over the two lakes, with part-time caretakers, and about twenty-five cabins.

After Clayton's death in 1921, Genia struggled to keep the fish business going and raise the children. Genia's mother moved in with her to help run the fish business, which the entire community tried to support. Neighbor Frank Swank from Castle Lakes and Frank Wills from Lake Cliff Dude Ranch collected green (undeveloped) Brookie eggs from nearby Road Canyon and delivered them to the Wetherill Fish Hatchery to be eyed and hatched. Green eggs are quite fragile and have very little ability to survive more than a few hours with disturbances. Green eggs had to be packed in layers of moss with brass screen cloth, with ice or snow over the top, and transported quickly.[78] Brookies spawn in the late fall, and early fall snows in the high country are quite common. Even with help, the fish work was grueling, cold and damp, so Genia eventually sold the hatchery operation

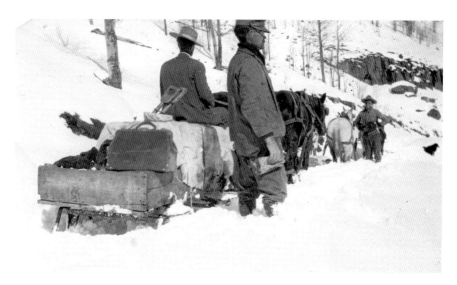

Transporting green Brook trout eggs taken in late fall from Road Canyon down to Wetherill's. Frank Swank is on the sled, Frank Wills is in front and a state fishery person is unknown, circa 1922. *Author collection.*

and started the Wetherill dude ranch at a location down the river. The Wetherill Ranch is now known as the R-Bar-C.

One of the early fishery developers with great entrepreneurial spirit was Bert C. Hosselkus Sr., who established one of the most successful commercial fishing businesses in southwestern Colorado. While the stage was still running from Del Norte to Silverton in the 1880s, Bert was a driver and saw many places along the route that he believed would be good locations for fisheries. One such location was Lost Lakes, on the top of Finger Mesa. Small dams had been built there to store water to sell to the San Luis Valley farmers, but Bert converted it into a cutthroat trout fishery, from which he sold eggs and fry. Lost Lakes has always been private, and it remains so today.[79]

Another site was along Crooked Creek, originally dammed in 1908, again for water storage. Bert purchased that site in 1912 and created what was to become known as the Road Canyon Reservoirs. The upper lake was used only for water storage; it was not stocked with fish. The lower lake, made deeper and larger by raising the height of the dam, had many different species of fish in it over the years. Hosselkus experimented unsuccessfully with Kamloops and Steel-head salmon, but German Tench flourished, which allowed him to ship about two tons of dressed fish out every two weeks.[80]

Tench are a large invasive fish native to Europe, introduced across the United States in the late 19th century for use as a food and sport fish. Tench thrive best in enclosed, preserved waters, with a clayey or muddy bottom and with abundant vegetation.[81]

For those who have fished at Road Canyon, it is obvious that this accurately describes those waters. In 1927, the introduction of Brown trout was also successful, and they were stocked locally in limited locations, as local fishery-men disliked the aggressive Browns. In addition to his significant dressed-fish business, Bert also shipped millions of durable eyed eggs throughout the country and to Japan, Germany and France.

Bert Hosselkus has received several hundred thousand Brook trout eggs this past week, and has his large hatchery filled up. It beats the band how Bert turns the trout out, dollars to doughnuts he can take a hen egg and hatch out a thousand of any kind of trout you ask for.[82]

In 1973, the site was leased to the Colorado Department of Wildlife, which eventually bought it and tore down the house and buildings, making a public fishing lake that is popular with fishermen.

And finally, we come to the story of fishing in the Rio Grande Reservoir. The dam was completed in 1912, establishing a long, narrow lake about seven miles in length, creating a different habitat for local fish. There was no fish-way around the dam, so fish trapped above the dam would be lost when the water was completely drained from the lake. And, if the gates were closed, there was no water for the fish downstream of the dam. Fortunately for the fish, two important things occurred. First, the dam was built in a rockslide, and

Hosselkus Family home at Road Canyon, circa 1940. *Courtesy of the Hosselkus Family.*

it leaked like a sieve from the beginning, so having water just below the dam was not an issue. Second, the Colorado Department of Wildlife, with prompting from area residents, required that the Farmer's Union folks be required to leave enough water behind the dam to provide a survival pool for the fish.

Shortly after the dam was completed, the Farmer's Union Irrigation Company, which built the dam and "owned" the water—and, by extension, the fish—applied for and received a "Lake license" from the Colorado state fish commissioner, which prohibited public fishing. Well, that decision was certainly popular with the locals—not! *Creede Candle* newspaper articles from 1918 contain vituperative language regarding the "bone-headed Fish Commissioner" and other complimentary remarks. The Farmer's Union had committed to establishing hatcheries around the reservoir that would provide eggs and fry to the state and establish even better fishing in area waters. However, the demand for commercial fish production in the Upper Rio Grande area was waning, as state and federal hatcheries came on line, especially those on the Front Range. As stated previously, the early 1920s saw the conversion of commercial fisheries to private fishing lakes. The need for hatcheries on the Rio Grande Reservoir disappeared. The state rescinded the Famer's Union lake license for the Rio Grande Reservoir, allowing the public to fish there. It remains a popular fishing spot.

A Tough Job

Neither snow nor rain nor heat nor gloom of night stays these couriers from the swift completion of their appointed rounds.
—Herodotus, used as the U.S. Postal Service motto

From 1860 to 1873, significant mineral discoveries were made in the Colorado Baker's Park region, also known as the Animas River Valley and known today as the Silverton area. Several mining camps and small communities were established to support the burgeoning mining effort. Until the railroad's arrival in Silverton in 1882, all materials and supplies came into the area up the Rio Grande route over Stony Pass by pack animals.[83]

Early mining camps were primitive, with miners living in canvas tents and derelict shacks. One of the early demands on a community was for communication with the outside world. In addition to miners needing to communicate with their families, businesses needed a (relatively) fast and reliable way to send and receive orders and information. Without modern-day e-mail or texting, communication depended on the mail. Creating local post offices was one of the solutions. Nearly every tiny mining hamlet, stage stop or actual town (such as it was) had a post office. Mail carriers were mountain men of extraordinary ability, courage, strength, endurance and fortitude.

The nearest major post office to the Animas River Valley was Del Norte, 120 miles east, which was served by a rail line. An independent

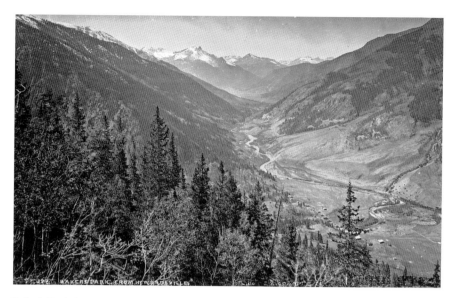

Baker's Park from Howardsville, circa 1883. *William Henry Jackson photograph collection. Scan # 20100751. History Colorado.*

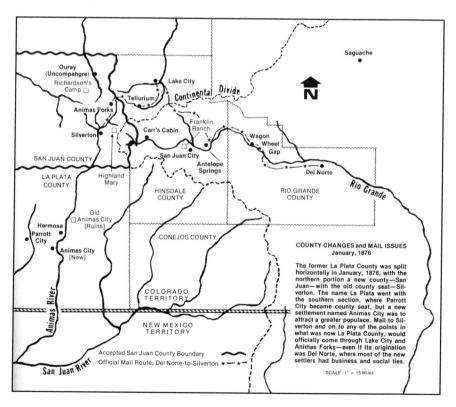

mail line contracted with the Del Norte post office to take mail farther up the river. Mail could be taken by coach as far up the river as Carr's Cabin, about a mile west of the confluence of Lost Trail Creek and the Rio Grande.[84]

From there, mail to the mining camps in the Animas River Valley was carried on pack animals when the snow was not deep or by men on what was known at that time as snowshoes. These were not the web-and-binding construct we know as snowshoes today, but old-fashioned wooden skis upon which the wearer's boots were tied. A single long pole used for balance and to propel the skier was placed between the legs and

Opposite, bottom: Mail routes, circa 1876. Many More Mountains, Vol. 1, *Allen Nossaman.*

Below: Miner's cabin in winter, 1883. *The Denver Public Library, Western History Collection, WHJ.10406.*

Remains of Carr's cabin, 2013. *Author collection.*

sat on for a brake. Mail was carried in a pouch crossed over the body or as a backpack.

During the winter of 1874–75, a snowshoe mail route was established from Del Norte to Baker's Park in the Animas River valley. At that time, it was run weekly from Del Norte to Antelope Springs, a distance of forty miles from the mines, for the carriage of mail. From Antelope Springs, the mail was taken by pack animal as far as Carr's Cabin, about half the total distance, and from there it was transferred to snowshoe delivery for the remaining twenty miles over very high mountain passes.[85]

In the early West, these small communities competed fiercely for anything that would provide them with importance, in the hopes that their community would grow and develop into a thriving center of business. In 1875, an entrepreneur, with what is assumed to be support from Lake City businessmen, managed to obtain a contract to deliver mail to Silverton from Saguache through Lake City. This new route traveled from Saguache to Los Pinos Indian Agency to Lake City to provide a regular weekly mail service. This venture was promoted to make these towns of more significance than any along the Rio Grande route. An increase in frequency of mail service to three times a week was promised as part of this grandiose scheme. The snowshoe mail route to

Silverton required tough and hardy men, as there was no direct route through these treacherous mountains.[86]

However, in the winter of 1875, the town of Animas Forks (present-day Silverton) was deserted, the number of its heretofore numerous inhabitants having dwindled down to the two mail carriers. Mail service was, therefore, suspended. The following winter was a different story. The mining camps did not shut down for the winter, numerous inhabitants were in residence and mail was expected to be delivered three times a week. Descriptions of the hazards and life-threatening conditions for the mail carriers between Lake City and Silverton were horrendous, and the mail carriers stated that the Silverton folks should be thankful for mail once a month. A specific example of these dangers was documented in a newspaper article from the *Colorado Springs Gazette* of January 29, 1876.

> *T.G. Andrews, a mail carrier on the route between Lake City and Silverton, recently avoided seven snow-slides between the Forks and the foot of the mountain, about a mile from Tellurium. He was then caught in a slide that came rushing down the mountain from 2,000 feet above him, carried into the flat below, a distance of 400–500 feet, and completely buried him. Succeeding in reaching his arm up through the snow, he soon wriggled himself into daylight, but with the loss of his snow-shoes. Subsequently, the same carrier was caught in a storm, and had to remain out overnight, having his ears, hands, and feet frozen.[87]*

In the winter of 1876, the good citizens of Silverton and vicinity received mail three times in December and not once in January, leading them to make a protest to Governor John Routt. They stated that the existing postal route along the Rio Grande from Del Norte via San Juan City had been used as the only source of supply since the Las Animas valley opened to settlement. This route is passable by wagon nine months of the year from Del Norte to Carr's Cabin and by pack animals or on foot from there to Silverton. The depth of snow determines the mode of travel from there to Silverton. In the winter, mail carriers would snowshoe (ski) from Carr's cabin to Silverton. The protest of the Animas Valley citizens did not go unheard; in the summer of 1876, the route from Lake City was abandoned in favor of the Rio Grande route.[88]

A legendary figure, John "Jack" Grinnell (or Greenelle), and Hans Aspaas were awarded the postal contract from Del Norte to Parrott City, which would take them through Howardsville, Silverton, Hermosa and other towns in the Animas River valley along the way. They, and other men they hired, ran an

Skiing over a high Colorado mountain pass, circa 1883. *The Denver Public Library, Western History Collection,* X-334.

effective mail service for the citizens of the valley. As the mines remained operational even during the winter months, often, the only contact the people had with the outside world was via mail carriers. Grinnell was renowned in the area, and when he was presented with an opportunity for year-round mail service, he created the "Snow-shoe Line" between Del Norte and Silverton. Also the sheriff of Silverton, Grinnell, being made of stout stuff, was undaunted by snowshoeing many miles with vertical climbs of over two thousand feet, many above the timberline. On November 28, 1876, Grinnell left Carr's Cabin on a Tuesday morning with the confidence of a man who had completed this trip many times, heading for Silverton and planning to be back by Wednesday evening. When he did not arrive in Silverton by Friday, searchers went out and found Grinnell's lifeless body with the mail pouch clutched in his hands, about three hundred feet below the summit of Stony Pass. Years of heroic labor in delivering the mail, and damage to his body from dealing with the "rough customers" around mining camps, eventually took a toll on his body. In a letter written to his brother shortly before his death, Grinnell implores him not to tell their mother that he had been stabbed.[89]

Harriet Louise "H.L." Wason, (Mrs. Martin van Buren Wason), of the Wason Ranch near present-day Creede, penned in 1887 the following ode to Grinnell, remembered from her days living in Silverton.

With a swinging gait, he started,
Secret triumph in his face;

Confident and happy-hearted,
Quickening not his measured pace,
Till our eyes no longer noted—
When we turned us with a jest,
And of all our friends, we voted
"Jack" the bravest and the best.

Sublime in his manhood, supreme in his might,
No terrors for him had the pitiless white
That covered the chasms and gulches from sight,
And left but a desert all trackless and wide,
Entombing the trail o'er the fearful Divide.

And Cunningham spotless lay bright in the sun,
With no boundary to mark where the foothill begun;
At the summit a tremor of fear pierced his brain,
An horror embodied looked up from the plain,
Where even in summer, a silence like death
Chills the blood of the wayfarer, numbing his breath.

In the horrible vastness, converging to haze
Where Stony Gulch elongates under his gaze,
It was there where he fell, with the blue heavens o'er him,
The white sea and solitude stretching before him.

We marked where his footsteps had faltered, could tell
How bravely he struggled to win e'er he fell,
Hearing pulse, thro' the silence, the waves of his knell,
Tracing ever a circle, despair leading blind
To the void of stagnation, he deemed behind.

Ye who have seen Stony when summer suns shone,
Imagine him there in the winter, alone?
Can words paint the horror that turned him to stone!

Yet the sleep that God gives his beloved had crowned him
On his couch with the cloak of the weary around him
At peace with himself and his Maker we found him.[90]

111

Doubtless many winter tragedies occurred to these fearless mail carriers. Years later, another documented tragedy occurred near Silverton. Ophir was a mining town that was reached from Silverton over Ophir Pass. Ophir, as were many high-mountain mining camps in the winter, was in constant danger of avalanches, which swept away buildings and made travel treacherous. A Swedish mail carrier, Swan Nilson, who traveled frequently between Silverton and Ophir, was killed while taking Ophir's Christmas mail from Silverton over the pass. Although paid handsomely for this treacherous winter trip, he was no match for the thundering avalanches that swept down the mountain. Many searches were conducted for his body over the next several months, leading some to suspect he had absconded with the mail. He was discovered by his brother sometime later on a hillside, with the mail pouch still on his back.

> *Ophir's Christmas Mail: An old-timer's version of a half-forgotten incident in the early San Juan*
>
> *'Twas the night before Christmas and stormy, the snow fell thick and fast*
> *And down the canyons and gulches the wind blew a terrible blast*
> *The winter that year set in early, 'twas the winter of '83*
> *The mountains with ermine were covered, as far as the eye could see*
> *At Silverton, up in the mountains, Swan Nilson, who carried the mail*
> *To the mining camp of Ophir, was preparing to start o'er the trail.*
> *In vain friends tried to dissuade him from attempting the trip that day*
> *The brave mail carrier ne'er heeded their warning, but went on his way*
> *For, said he, the good friends at Ophir disappointed will be if I fail*
> *There'll be no Christmas at Ophir if Swan Nilson don't bring up the mail*
> *The storms, increasing in fury, raged through the entire night*
> *Hiding the whole rugged landscape with its pitiless mantle of white*
> *Next morning the blizzard was over, search parties went out on the trail*
> *But they found not the faithful mail carrier, nor Ophir's Christmas mail*
> *But the path of more than one snow slide told "the good friends at Ophir" the tale*
> *How the brave mail carrier had perished and the loss of their Christmas mail*
> *'Twas the following fall when they found him, late August now I recollect*
> *How with red and yellow and orange the slopes of the mountains were decked*
> *The sun had melted the snow slide and strapped to his back goes the tale,*
> *They found the missing mail pouch, and Ophir's Christmas mail.*[91]

Because of the hardships on human mail carriers, in 1877, Otto Mears attempted an alternative mode of winter transport, using dog sleds to move mail and supplies from Silverton to Ouray. He went north around the main body of the San Juans to avoid the steep and treacherous passes. The dogs, however, would leave the trail in pursuit of game, eat foodstuffs in the packs, fight with each other and smash women's hats in transit. A single season convinced folks that dog sleds just weren't practical in the San Juans.[92] Therefore, the duty fell back on the frailty of men on skis, best summed up again by H.L. Wason:

> *These tales are pitiful, and seem*
> *Like horrors of a fever dream*
> *To you who listen, I who tell,*
> *Know their reality too well,*
> *Remember, too, the first who died*
> *As a carrier on the Great Divide.*

Lost Trail Station

National Historic Site on the Upper Rio Grande

Just a place in the mountains, no, my place in the mountains, the San Juan mountains of Colorado, fifty miles north of the New Mexico border in the southwest corner of the state. I was raised there; my beliefs formed from the mountains that surround this land, strong, long-lasting, and changing slowly, only with great effort from some outside force.

I go back there as often as I can, if not in person, then in my mind; either way it brings needed refreshment to me. One-hundred sixty acres make up Lost Trail Station. Some cabins and the old barn, a long low building with stalls for twenty horses or mules, smelling of old leather and fresh manure. One-hundred and fifty-five acres covered with aspen and Blue Spruce, the trees yielding to open meadows along the river, the Rio Grande, large, deep and cold in the spring, swift but smooth and gentle in the fall. Walking through the trees, sunshine streams through the canopy of branches making mottled patterns on the forest floor, one can feel the mountains, the loneliness of the first people to see this country, the wonder that the animals must feel being a part of all the splendor that is all around, not fully understanding what part they play in the whole pattern. The mountains striking the sky, smooth alpine meadows, roaring streams—all of this making up my playground.[93]

The land is covered with a thick layer of snow many months of the year. As spring comes on, the wildflowers create a riot of color, hummingbirds migrate and babies are born to the many deer, elk, bear and moose that

The road to Lost Trail Station. *Author collection.*

live in these high-mountain valleys. At ten thousand feet in elevation, spring comes late in the year, and winter comes early. Summers are glorious, and fall is too short, but the magnificent red, yellow and orange aspen leaves create a landscape that only nature can.

This area of southwestern Colorado was traditionally home to only those many animals that resided here. The predecessors of the Ute Mountain Indians moved into the area about two thousand years ago. The Ute people moved on foot to hunting grounds and gathering land based on the season. The high-mountain meadows were filled with deer, elk, moose, black bear and small mammals and birds whose only other predators were mountain lions and grizzly bears.

As Anglo westward expansion forced the Native Americans farther west, treaties were made and broken. The Utes were assigned a reservation that removed them from their rich hunting grounds in the meadows of the Upper Rio Grande. The lust for gold and silver in Silverton started an epidemic of human movement through the area; miners and others sought their fortune from the San Juan Mountains.

Following the Rio Grande River as it wandered through the wide valleys, the miners pressed on, around bend after bend. As the canyon narrowed, the resolute prospectors hugged the north bank of the river until they came to a swampy opening where willows and brush abounded; a number of trails seemed to take off in several directions, with no particular one seeming predominant. One to the right appeared to be as well traveled as any, but it was the wrong choice for many a passing company; the second choice was no more helpful. The fresh game readily available made camps pleasant, but forward progress between the last two camps sometimes netted only a short distance. The frustration felt at what came to be known

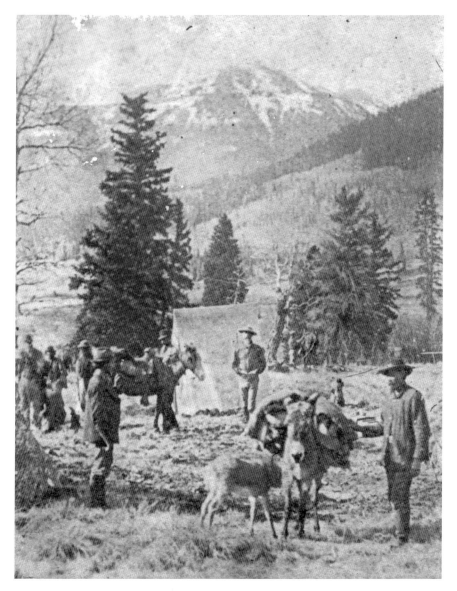

Lost Trail, near Barber's Ford across the Rio Grande. Simpson Mountain is in the background, circa 1876. *Hinsdale County Historical Society, 12995.*

as Lost Trail was perpetuated throughout the years by many a traveler. The name "Lost Trail" has been carried through time for this location on the Rio Grande route into the San Juans. As traffic increased through the area, by necessity the trail was better established, and men and animals were

able to work their way up the Rio Grande, benefiting from the improved track through Lost Trail.[94]

As the miners invaded the territory assigned to the Indians, and as conflicts increased, the U.S. government issued an almost yearly series of treaty "modifications" that drove the Utes farther west, attempting to remove them from the area the miners wished to develop. The Indians had to move to lands west of the 107th meridian. On paper, things looked good, but on the ground, the location of the 107th meridian was not where the folks back East thought it was, and this confused implementation out West. Therefore, in 1873, an expedition headed by Lieutenant Ernest Howard Ruffner of the Army Corps of Engineers set out to locate and map the 107th meridian to set the boundary of the Ute Indian Reservation. But its more significant charge was to find out as much as it could about what was beyond that boundary and either document or debunk the stories of mineral wealth that were the basis of potential conflict with the Utes. The Corps was also to analyze potential routes into the area in question. The party left its wagons at Camp Loma and set out late in May with thirteen pack mules and a mounted escort. The expedition's report noted that the settlements of La Loma north of the Rio Grande contained about twenty-nine houses. The men passed that site on their way to Camp Loma, noting that the newer town of Del Norte on the south side of the Rio Grande (which actually included the old La Loma plaza) had about fifty structures, mostly of log or adobe. Wagon Wheel Gap and Lost Trail were referred to by name on the route.[95]

> *This reconnaissance, and resulting report and map, was inspired by the silver and gold discoveries made in the late 1860s on the newly reformed Ute Reservation in the San Juan Mountains of the Colorado Territory. After Chief Ouray agreed to yet another "peace treaty" with the U.S. Government, the Utes were once again subjected to a loss of the property and consolidated on yet another smaller section of land known as the Los Pinos Agency and the White River Agency.*[96]

After the Ute treaty revision of 1874, the Upper Rio Grande and the route over over Stony Pass into Baker's Park were opened to the miners, and the influx began. It was just a trickle at first, as amenities and support along the way were limited and only the hardy and determined made the trek. From the town of Del Norte, Colorado, the most obvious natural route to Silverton was up the Rio Grande canyon as far as Stony Pass and then down into the Animas River drainage and Silverton—in all, about one hundred

miles. For nearly a decade, the road from Del Norte to Silverton over Stony Pass was the major access route by which tons of freight were hauled into the central San Juan Mountains and ore was hauled out. This route through the Continental Divide was taken by thousands of pioneers during the era beginning with Baker's Park's settlement in 1873. Traffic waned in the early 1880s, when the railroad arrived in Silverton.

Del Norte boomed with purveyors of goods and supplies for the miners; mules, donkeys, oxen and horses were in great demand. Stage stops seemed to grow overnight to meet the demands of the travelers. In 1874, San Juan City (the modern-day location of Freemon's Ranch), about sixty miles west of Del Norte, and the Jennison station, about seventy-four miles from Del Norte at the base of Timber Hill, were established in very short order. A few intrepid entrepreneurs loaded up supplies that they sold out of tents set up along the way to the miners traveling the route.[97]

As the mines at Silverton flourished, and more miners headed over Stony Pass, the need for supplies and animals only increased. In 1875, a tent site was established at the area known as Lost Trail by Frank Blackledge, who worked for the Greene Packing Company out of Silverton. He apparently maintained a good reputation with the Greenes but had raised some eyebrows with an early-summer incident in which R.F. Long (an Ouray founder) and his party had left some wagons and provisions in Blackledge's care at Lost Trail while they made a light trip across the divide. On their return to Lost Trail, Long and his men found everything burned to ashes except an anvil and a portable forge. Blackledge's conflicting accounts of what happened were never resolved.[98]

> *The Viets brothers had about 140 head of cattle, mostly American stock, which they drove from Missouri two years ago, stopping until last spring on the Piquetwire [sic]. They have sold all the butter they could make from the milk of twenty cows at sixty cents per pound. They will probably winter their stock in the vicinity of Del Norte.*[99]

The Viets brothers had a dairy herd that they kept at Lost Trail during 1875, from which they sold milk, butter and cheese to the miners. They had to bring the herd to Del Norte during the winter, as the snow was too deep around Lost Trail to keep animals alive all winter. In the spring of 1876, they took the herd across Stony Pass to the Parrott City area, where they could keep the herd all year long and where they were nearer to their markets with the mines and miners.[100]

Traveling the forty miles from San Juan City to Silverton on horse or mule was a significant challenge in terms of time and effort. Area merchants, businessmen and county officials recognized the need to improve travel and set about developing the trail from San Juan City to Silverton into a passable stage road as far as Lost Trail, about seventeen more miles along the route. A newspaper travelogue related the trip in the *Colorado Weekly Chieftain* of July 19, 1877.

> *Antelope Springs or Alden Junction* [modern-day Broken Arrow ranch] *is sixty miles from Del Norte, and is the junction of the roads from Silverton fifty miles west and Lake City thirty-five miles northwest. Its altitude is 8,500 feet, and Clear Creek unites with the Rio Grande a few miles further west. Mr. Alden is among the pioneers of the country and thoroughly posted in its business developments and mineral resources. The principal stops on the road to Silverton are San Juan City* [modern-day location of Freemon's Ranch], *6 miles, where C.W. Brooks keeps a ranch and stopping place. At Antelope Park* [modern-day San Juan Ranch], *8 miles, J.P. Galloway has a commission and forwarding house, where freight generally is transferred from wagons to pack trains. At Lost Trail, 25 miles, J.T. Barber has a storage and commission house, and at Carr's Cabin all goods break bulk* [breaking down from large containers on a wagon to smaller ones that can be packed on an animal] *Joel Brewster presides over the stopping place here. Mr. W.M. Wilson carries the mail tri-weekly from Antelope Springs to Silverton; a two-horse hack is used as far as Carr's Cabin, and from there pack animals are substituted.*[101]

The spring of 1877 found John T. Barber of Quincy, Illinois, establishing a permanent station at what he called Lost Trail Station just up the river from the traditional Lost Trail location. The natural forage, the water and the protected location of the Lost Trail Station site would have been near ideal. It was situated about seventy miles from Del Norte and thirty miles from Silverton. John and his wife, Francis, took advantage of the water and ample meadows of the site and mastered the roles of hosteller, cook, livery man and packer required of a couple seeking to survive and serve along the road to Silverton and Baker's Park. The couple had three children: Othello, who was crippled; Fannie; and Frederick, named after an uncle who would join them with his wife, Lydia, and three children, Levi, Jenny and Charles before the decade ended. John and Francis Barber moved

Lost Trail Station barn, dating from 1877, is seen here circa 1930. *Author collection.*

This photograph of the interior of the 1877 Lost Trail Station barn was taken in 2014. *Author collection.*

their family into Del Norte for schooling with the onset of winter in 1877, leaving John Fippin in charge of the station for the offseason. The site included homes for the families, a hotel, a blacksmith shop, a store and, of utmost importance, the barn.[102]

The Lost Trail Station Barn is the last remaining barn along the original stage route from Del Norte to Silverton. It is believed to have been in continuous use since 1877. The barn is built of log and is approximately

nineteen feet by seventy-three feet in size and has a gambrel roof. It currently sits on a stone foundation. There is no evidence of nails used in the initial construction. The corners were square notched and mostly saw cut. When longer logs were necessary, they were joined with square cut lap joints. The trees were obviously selected for a standard size, straightness and minimum taper; they were laid up with the tapers in opposite directions. The result was walls that required a minimum of chinking and were very stable. The roof is currently metal and still has the original slab roof underneath. Originally, there would have been two large doors on the northern and southern ends of the barn when it was a stagecoach stop, but since then it has been altered to function for the ranch. The east façade has two entrances with doors of vertical boards and three small square uncovered window openings. There is also a small window opening on the northeast side of the barn. There is a platform on the north side of the barn to access the north gable end of the hayloft.[103]

Business at Lost Trail Station was booming, and mail service was a big part of the effort. The Lost Trail post office was established on January 28, 1878, with John T. Barber as postmaster. In July 1878, John Enfield advertised that he had a four-horse express wagon to carry the mail from Del Norte to Baker's Park. But the fine print admitted that the wagon only went as far as Barber's Lost Trail Station, where relays of saddle ponies were in readiness to carry the mail over Stony Pass to the other side. Travelers were also accommodated with horses, mules or burros at Lost Trail for the arduous trip over Stony Pass. As this was now the end of the wagon/stage road, Barber was also responsible for "Freight Forwarding and Commission," meaning freight arriving in wagons would be forwarded on to Silverton with the use of pack animals, and a commissary was on-site to make food and supplies available to be purchased.[104]

The San Juan mining fever had not abated, and in 1878, a correspondent of the *Colorado Weekly Chieftain* Pueblo newspaper again made the trip to the mines at Silverton and wrote an article of the adventure. The story is joined at Alden's Junction, where the stage route divided to go west to Lake City or south to Silverton. In contrast to one year before, note that a stop at San Juan City is not mentioned, and the site was probably in a steep decline, if not abandoned by this time in favor of traveling directly to Lost Trail Station before having to transfer to horse and mules.

Here we were met by Mr. John Enfield, a jolly good fellow, who carries the mail and express between Antelope and Silverton. We are conveyed

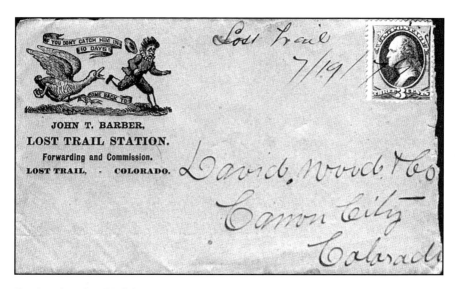

Envelope from Lost Trail Station post office, Lost Trail, Colorado, circa 1877. *Author collection.*

in a spring wagon from here to Barber's ranch, which is kept in excellent style by Munkers and Matthews. This [Lost Trail Station] is headquarters for pack trains on this side of the range, and a great resort of the burro freighters. This is the present end of the stage line, although there is a sort of wagon road all the way to Silverton. Our old Del Norte friend, Judge A.S. Goodrich, keeps a store here comprising a full line of such supplies as are required for the freighters across the mountains, and it is quite a lively place when several pack trains come in at the same time. The place is properly named Lost Trail, and here our jolly friend Enfield discharges us into the tender care and keeping of his partner, Mr. Tibbey, who packs the mail express and passengers from Lost Trail to Silverton on mules, horses and burros. Mr. Tibbey is one of the best fellows in the mountains and makes a boast that he can accommodate all that apply. He has side saddles for ladies, California or Mexican saddles for gentlemen, and pack saddles for jackasses. Your regular pack saddle is a miniature edition of a saw buck or a saw buck is an overgrown pack saddle, just as you please to have it. To properly pack an animal for this mountain trip requires great skill, good judgment, and strong rope, and may be set down as one of the fine arts in this part of the world—but Tibbey knows how to do it.[105]

In the spring and early summer, traffic headed west to the mines, and in the fall, just the opposite. As John Curry succinctly put it in his journalistic reminisces in the *La Plata Miner* four years later, "From October 10 to 20, 1878, all parties who intended spending the winter in the east left Silverton." They trudged over Stony Pass, which took them over the Continental Divide, past the new work of Squire Watson and his family on Grassy Hill, and Joel Brewster and his clan on Timber Hill. Virtually all of the travelers were afoot or on horseback, the more affluent transferring to wheeled conveyance at Lost Trail Station to continue the seventy-mile trip to Del Norte. Most would continue walking to Antelope Park and catch a stage or buckboard from there. Others would walk the one hundred miles from Silverton all the way to Del Norte, just as they had come.

Providing mail to the mines in and around Silverton was always a challenge. Although grand promises about regular delivery were made, the reality was usually significantly different. Lorenzo Brewster had made one trip over the divide with no pay sometime in February 1879, carrying what he could from Timber Hill and Grassy Hill and bringing mail out of Silverton. Mail service was promised to begin by the first of March and occur six times a week. When nothing arrived in Silverton, the locals collectively asked one of their own to make the trip over Stony Pass to Lost Trail and bring back any mail stored there. When the Silverton volunteer reached Lost Trail, he was astonished to find all the mail dispatched east from Silverton still there. He returned with three hundred pounds of incoming mail.[106]

The road from Lost Trail Station to Silverton was completed in 1879. The role of Lost Trail Station was significantly diminished, as it was no longer the end of the road. Travelers could simply go right by without stopping. However, it was seventy miles from Del Norte and about seventeen miles from Galloway's, so there was still a need to change stage horses, and some traveler accommodations continued to be provided. Between the loss of business and the physical demands of running the stage station, which were too much for Francis Barber, the entire family returned to Illinois for her health in their second winter of 1879. The Lost Trail Station post office was rescinded in September 30, 1879.[107] The Barbers leased the hotel to a pair of gentlemen named Matthews and Munkers, two men who had been with Frank Blackledge in the Animas canyon in 1877.

The Denver & Rio Grande train tracks were completed to Silverton in 1882, and this further impacted the business at Lost Trail Station. Few travelers now used the stage road, instead preferring to take the train. The Lost Trail Station Post Office was discontinued on September 30,

1879; it was reopened for about a year by Eugene C. Hamilton in May 1883 and discontinued in August 1884. Although the post office came and went in this period, the hotel and livery supporting the stage route remained in operation at least until 1885. Harlow J. Holdredge started postal operations in June 1892 to support the nearby Beartown boom and discontinued them in May 1894, corresponding to the closing of the mines at Beartown.[108] During this short period, a restaurant and a supply store were also established. Over the next several years, the importance of the stage route that passed through Lost Trail Station was increasingly diminished; eventually, the site fell into disuse.

As the mines and their riches enticed many people to the mining towns and camps in the mountains, nearby San Luis Valley was attracting farmers and ranchers who supplied meat and produce to the miners and the growing Front Range of Colorado. The large cattle herds were taken from the San Luis Valley to the mountains for summer grazing, and Lost Trail Cow Camp grew out of the old Lost Trail Station site, especially because there were cabins and a barn available for the cowboys to use for themselves, horses and sick cattle. The Lost Trail Cow Camp was used for many years as a base when the cowboys spent the summers riding the range and caring for cattle. It wasn't the same as the livery days, but there was still a fair share of horses and cowboys.

In 1902, there was a severe drought on the Navajo reservation. The Navajo animals were dying of starvation, as there was no rain for the grass to grow.

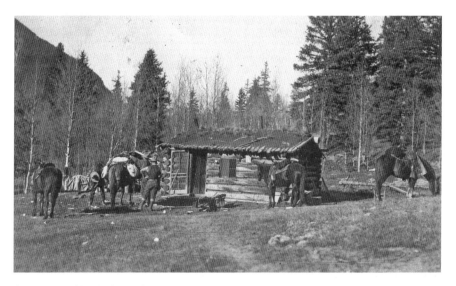

Cowboys packing in front of 1877 Lost Trail Station cabin, circa 1927. *Author collection.*

Navajo cowboys training horses at Hermit Lakes, circa 1902. *Author collection.*

Richard Wetherill had a trading post at Chaco Canyon on the reservation, and his brother Clayton and brother-in-law Charlie Mason had ranches at Hermit Lakes, on South Clear Creek, a tributary of the Rio Grande. Every summer, Richard drove his own animals over from Chaco Canyon to Hermit Lakes so they could eat the plentiful grass and have ample water. With the drought, Richard told the Navajos to gather all of their pregnant sheep, goats, cattle and horses to take up to Hermit Lakes for the summer. Up there, the animals would have adequate food and water and be able to safely have their babies.

Clayton and Charlie rode to Chaco Canyon to meet up with Richard and the Navajos, who would be driving their animals over Stony Pass to Hermit Lakes. It was a sight to behold when they came into the lush meadows of Lost Trail Station: hundreds of ewes, does, cows, and mares, along with the cowboys and beautifully dressed Navajo herdsmen. They stayed a few weeks and then moved farther east to Hermit Lakes to spend the summer. In October, the herd returned here on its way back to Chaco Canyon. The babies born over the summer were strong and healthy, having spent several months eating the high-mountain grass and playing. It was wonderful to see

Early winter snow at Lost Trail Station, circa 1950. *Author collection.*

both the humans and the animals revived and refreshed for their trip back to New Mexico. An early-season snowstorm kept them at Lost Trail Station for several days. The herdsmen and cowboys stayed in the old cabins on the hill. When the weather cleared, they went over Stony Pass and back down to Chaco Canyon, having avoided what could have been a devastating summer for animals and men alike.

In June 1914, a San Luis Valley rancher, Loren Sylvester, thought to bring up some true Texas longhorn cattle to the Colorado mountains. These cattle were the first of their kind on the open mountain ranges, and it was not known how they would react in such remote country. Seventeen carloads of longhorn steers were brought up to Creede by train on cattle cars, unloaded, and driven to the high-mountain meadows. These steers had a wild summer, becoming almost feral in the high mountains. They strayed as far north as Gunnison, west to Silverton and south to Durango. The wild steers were impossible to drive as a herd, so during fall roundup the cowboys had to tie them together in twos to keep them in some semblance of a herd. This involved the cowboy roping one animal around the horns and tying him to a tree. The cowboy then roped another steer around the horns and dragged him over to the same tree, where the right horn of the left-hand animal was tied to the left horn of the right-hand animal. Thus tied together, the two

steers could be driven along (kind of). With the funniest-looking herd of tied-together steers, the cowboys were able to move them down the trail to the corrals at the railroad spur at Wason ranch outside of Creede. There they were finally loaded back into cattle cars and sent to the stockyards in Denver, never to be seen again in the high-mountain meadows of Lost Trail Cow Camp.

> *L.B. Sylvester unloaded 17 standard gauge cars of cattle at Wason last Monday. The animals coming direct from El Paso, Texas. There were about 450 head and they are to be ranged in the Lost Trail creek country.*[109]

Prior to the advent of the railroad into Creede, drives started down in the Monte Vista area of the San Luis Valley and required driving the herds all the way up into the meadows of Lost Trail Cow Camp, a distance of about ninety miles. These drives required at least a couple of weeks and were hard on man and beast. With the arrival of the train tracks as far as Creede, the area ranchers took advantage of this convenience and shipped their animals back and forth from the San Luis Valley on cattle cars. The train saved many days of work and was easier on both the cattle and the cowboys. However, during World War II, train cars were diverted to support the war effort. The local ranchers were told that there were no cattle cars available to transport cows from the San Luis Valley to Creede. Not to be deterred, area ranchers contacted former Colorado governor Billy Adams, a local cattle rancher in his day, who was able to intervene with the railroad managers and have cattle cars sent up to Creede. This saved the cowboys from a multi-day drive back down to the San Luis Valley, which would have been not only expensive, but dangerous, since there were so many more vehicles, fences, roads and people to contend with than in earlier years.

On June 15, 1905, President Theodore Roosevelt established a forest reserve in southern Colorado known as San Juan Reserve, containing about fifteen thousand acres. The area included the continental divide, and extended down to the foothills on each side. Portions of Hinsdale and other nearby counties were included in this reserve. The purpose of the reserve was to protect the trees and snowpack, which by necessity limited the number of animals that could be grazed on these lands. Eventually, the U.S. Forest Service assumed management of the national forests and wilderness areas that surround Lost Trail Station.

The former Lost Trail Station/Cow Camp was patented as approximately 160 acres of private property in 1917 by Susan Jackson Tice. She had

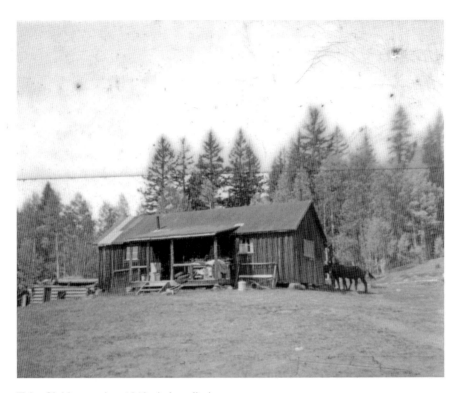

Tulsa Clubhouse, circa 1940. *Author collection.*

applied for the patent several years earlier but died before it was granted, so the property went to her family, who sold it to William Brown in 1921. In 1923, William Brown retained five acres and sold the remainder of the property to the Tulsa Rio Grande Club. This group of wealthy Oklahoma fishermen had gotten together and formed the club, enabling them to use the ranch as a fishing resort. There were to be numerous individual cabins, but they were never built. The site contained a main clubhouse, the Tulsa Clubhouse. It was the only structure ever built, near to some of the old stage stop cabins.

The remoteness of the ranch, the poor condition of the rough dirt road along the river and the Great Depression all contributed to the lack of development of the property by the Tulsa Rio Grande Club. The absence of landlords resulted in the property being used by squatters, tourists and vagrants—with the associated vandalism of the old stage station buildings. In 1932, a Monte Vista rancher wrote a letter, asking for permission to use the lush mountain pastures that are part of the ranch for his summer horse pasture. In return, he would care for the place.

Mr. B.H. Higgonson
Tulsa, Oklahoma
Dear Sir:
I do not know Mr. McGee's address. I suppose he is still President of the
Tulsa Club, and I wanted to know if I could camp in the little cabin and
have the horse pasture this summer. I will keep the fence up, which is in a
bad shape, and clean out the ditches and put the water in the pasture. There
wasn't any water on it last summer.

I am not making any tourist camp out of it, or running any tourist
horses, but would gladly let any of your people have a horse anytime, and I
will try and look after it the same as if it was my own. But the way it was
this last summer everyone seemed to have a right and I didn't like to camp
there without permission. Will you bring this up with the others and let me
know. Thanking you, I remain yours truly,
H.J. "Hi" Miller, Monte Vista, Colorado, Route 2, Box 16.[110]

In September 1938, Carrol Wetherill purchased from William's son Jim Brown the five acres and built several cabins to use as a dude ranch. The land was on the far end of the property from the barn and original stage station site. In the ensuing years, Carroll contacted individual Tulsa Rio Grande Club members and slowly purchased their shares from them. He developed the former Lost Trail Station site into what is now a working ranch, which has been in the Wetherill family up to this time. In 1941, the barn was jacked up, and the rotten logs sitting on the rock foundation were replaced. He also re-roofed the barn with board and batten. In 1987, the roof was covered with tin. Although the original wood remains, this project prevented further deterioration of the roof and controlled leaks.

In 2009, the owners of Lost Trail Station started the process to propose the site for inclusion in the National Register of Historic Places. The Lost Trail Station has historic resources significant under criterion A at the local level for its association with shipping, packing, and freighting through central Hinsdale County from 1877 to about 1895. The barn is a rare remaining building in the county associated with transportation during the period of significance. It played a critical role in animal transportation in the early years of mining in the San Juan region. This property also holds significance under criterion C at a local level for architecture. The barn is an excellent example of log architecture. Great craftsmanship is observed in the construction of the barn, and it is a well-preserved example of local

Cabin No. 1 at Lost Trail Station, built in 1939 by Carroll Wetherill and seen here circa 1948. *The Denver Public Library, Western History Collection, X-4201.*

Lost Trail Station barn in 2015. *Author collection.*

construction using locally harvested materials. It is the oldest of three historic log barns in Hinsdale County. The resources on the property show a good example of ranch life in historic times. There are buildings, a corral and a pasture. The historic setting gives a useful understanding of ranch life and ranch development and how it relates to the natural landscape. The barn and remaining original cabin also illustrate the diversity of function throughout its history. Although it was originally constructed to serve as a stagecoach stop and freight-forwarding business, the barn offers insight into how structures can serve different functions over time. The setting has been well preserved and still functions as a ranch today.[111]

Taken together, the uniqueness of the Lost Trail Station site and its impact on regional history was determined to be significant. Approval for listing in the National Register of Historic Places was granted on April 27, 2011. After 134 years, surviving Colorado mountain weather conditions at ten thousand feet elevation and serving many purposes, the Lost Trail Station stage stop has been recognized for its contribution to the development of the area. Conducting research and obtaining funding to restore the barn and associated outbuilding to their 1877 condition is ongoing.

Over the years, the winter snows have taken their toll. I have weathered many storms, but my age is starting to show. My roof is falling in, and big logs are shifting out of place. I don't want to fall down on the job! Now, my family and friends are seriously concerned about my welfare and are working for my preservation and restoration—and to allow good folks to come and hear my story.[112]

THE CREEDE HOTEL THROUGH THE YEARS

The very first Creede Hotel was called the Creede Camp Hotel and was a small log cabin affair, something to meet the needs of people flocking into the Jimtown-Creede area. To meet the demand, a new hotel was quickly constructed—a milled lumber building erected by I.R. McCleod. Ira, a successful businessman who owned a saloon in Creede, saw an opportunity to develop a good hotel. This building became known as the "big" Creede Hotel and was located in Creede, or "Upper Creede." Of course, with the huge influx of miners and others to the area, Creede had need of numerous hotels. Some of these were little more than tents, and many did not last long. But, they met the needs at the time.

In 1891, Susan Ingle McLeod Archer Jackson Tice, Ira's sister, came to Creede, and she and her older children took over the operation of the first Creede Hotel.

> The Creede Hotel. conducted by Mrs. S.I. Tice & Son, is one of this best kept houses in the camp and enjoys a large patronage. It is popular with transients and regular boarders.

> As the two camps are so closely connected, one may walk from Creede to Jimtown in a few minutes. Jimtown boasts of one public eating house, designated as the Creede hotel, and one newspaper, and a few shanties and tents.[113]

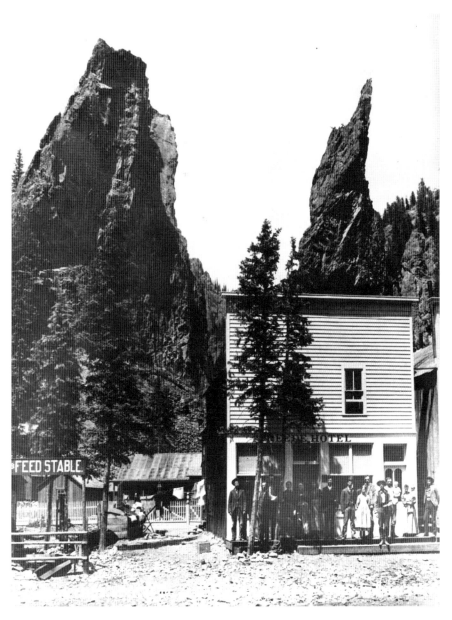

Creede Hotel, established in 1891 by Susan McLeod Archer Jackson Tice, who is one of the ladies standing on the porch with some of her children. *The Denver Public Library, Western History Collection, X-7472.*

Creede Hotel.

S.I. Tice and Son, Proprietors.

Good Accommodations for transients.

Table the Best the Market Affords.

Next door to Bank, Creede.

Creede Hotel advertisement, 1892. *Colorado Historic Newspapers online*, Creede Candle.

The original Creede was a little town strung along East Willow Creek at and above its junction with West Willow Creek. It had been started with the early silver finds in 1886 and named Willow. With the big silver strike of Nicolas Creede, the miners agreed to rename the little town Creede in 1890. Being somewhat older and less a product of the "boom" mindset, Creede was of better and more deliberate construction than nearby Jimtown, which sprouted up overnight in 1892. Jimtown, much larger and with a greater population, was a mile below where the canyon widened, where Creede is today.[114] Unfortunately, as was common in the hastily constructed early mining towns of the West, a large fire on June 5, 1892, destroyed nearly all of Jimtown. Creede was mostly unscathed by the fire. The Creede Hotel survived the fire of 1892 and continued as a small facility that supported the area until Jimtown could be rebuilt.

> *Mr. S. Hubbard and Miss Myrtle Jackson were united in matrimony at the Creede hotel last Saturday evening. Mr. Hubbard is a well-known business man having interests in Creede and at Del Norte, and Miss Jackson is a daughter of Mrs. Tice, proprietress of the Creede hotel.*
>
> *A social for the benefit of the Methodist Sabbath school was given in the Creede Hotel, in the upper town, Tuesday night.*[115]

After the 1892 fire, Jimtown was rebuilt at an amazing rate. Buildings went up overnight, and construction was of varying degrees of quality and haphazardness, depending on the crew. There was silver to be mined, miners had money to spend and the buildings must go up! Lumber would arrive on the train in the morning, and the owners of a new cabin would be cooking supper in it by sundown.

It was into this maelstrom of building frenzy that a couple named John and Elizabeth "Lizzie" Zang arrived from Denver, where they had operated

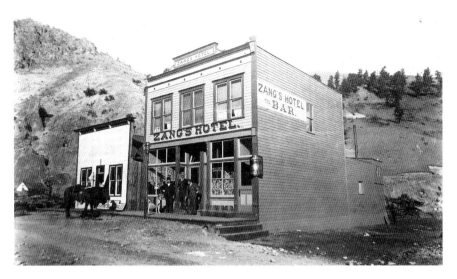

Zang's Hotel, the second big Creede Hotel, established in 1892. John may be the man standing on the porch. The hotel burned down in the Creede fire of 1896. *The Denver Public Library, Western History Collection, X-7473.*

a thriving hotel. The couple, having come to the United States from Germany in 1880, built and operated a successful hotel in Georgetown, Colorado, and later repeated the same process in Denver, Colorado. In the late spring of 1892, lured by the torrent of miners to the area and knowing that booming mining camps were unique opportunities, they moved to Jimtown and erected a large and opulent building known as Zang's Hotel, which was open for business as noted in the local newspaper on July 29, 1892. It is possible that John Zang had already started construction on a hotel in Jimtown when the town burned in June 1892, as evidenced in the local paper dated July 5, 1892: "John Zang is rebuilding on his old location in the burned district [Jimtown]."[116]

As Jimtown was rebuilt and growing at a fevered pace, the good residents of the town decided that they wanted the name of Creede, after Nicholas Creede, for themselves. So, in 1893, they appropriated the name, "leaving the old town to get what consolation it could out of being known as Upper Creede."[117] With Zang's Hotel in operation in new Creede, Susan and family looked elsewhere for opportunities and established hotels in Spar City and Beartown.[118]

Consistent with the name change, Jimtown-Creede folks also decided that they would assume the role of Mineral County seat. The decision made, the good folks of Creede went to the provisional county seat at Wason and

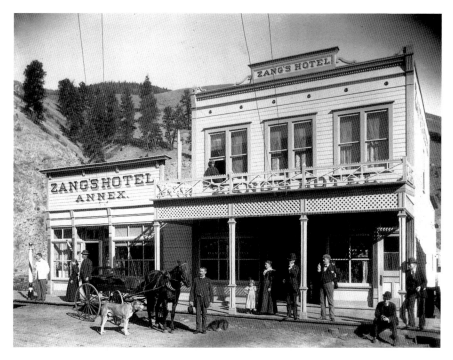

Above: Zang's second hotel, almost like the first, is seen here, circa 1897. *The Denver Public Library, Western History Collection, X-7474.*

Opposite, top: Rear view of Zang's Hotel. *The Denver Public Library, Western History Collection, X-7910.*

unceremoniously removed the records and took them back to Creede, where they remain today. Raiding county records to establish a town as the county seat—with attendant power and authority—was actually an oft-practiced occurrence in the mining towns of the West.

Zang's Hotel was a first-class operation. It was highly regarded, and the hotel operated with great success for a couple of years, until another of what was to be a series of large fires swept through the town of Creede. This blaze destroyed virtually all of the town in 1896. Zang's Hotel burned to the ground, along with all of its lovely furnishings. However, the plucky Germans built the second Zang's Hotel at the same location, although with a somewhat smaller footprint.[119]

The Zangs ran a respectable establishment and paid a "bouncer" to keep order in the place. However, as with many hotels then and now, prostitution was also a big business, although kept to "cribs" out back, where the ladies of the evening plied their trade and dance-hall girls had dressing quarters.

Zang's Hotel Sample Room, seen here circa 1896, still stands today as a private residence. Note the brick construction. *The Denver Public Library, Western History Collection, X-7475.*

Beyond simply providing room and board and maybe some recreation, the function of a town's hotel was also to provide space for visiting physicians, dentists and traveling salesmen. Having commercial space allowed local residents some of the benefits of big-city living. To accommodate these needs, which grew beyond the scope of his hotel, John Zang built an auxiliary building as a "Sample Room" to provide more space for all of the visiting professionals.

> *Dr. Milton, the dentist, will be in Creede, at the Zang hotel on July 20th, to remain about one week.*

> *Dr. Scranton, will be in Creede at the Zang hotel for the next two weeks.*

> *EYE MAN IN TOWN at the Zang Hotel*
> *Prof. Fisher of Denver and San Francisco is again in the city. He has been visiting Creede off and on for the past nine years and everyone he has served speaks highly of his thoroughness, as Prof. Fisher has made a specialty in fitting glasses to all defectives. Glasses fitted to all kinds of defective eyes and satisfaction guaranteed. As Prof. Fisher will only be in the city until Tuesday next, those afflicted should call on him at the Zang Hotel.*
> *Millinery Miss McDonald with her stock of millinery is located in the Zang Hotel dining room temporarily, at the service of the ladies of Creede in re-trimming and altering hats and supply anything in the millinery line. Call and see me for the next few weeks at the Zang hotel and thereafter at my permanent location next to the courthouse.*[120]

As the Zangs' interests turned to developing other nearby properties, they leased out the hotel to a series of managing operators, some better than others. While John made investments and improvements to the hotel over the years, he was focused on his new projects. At one point, he and his wife even left the area, but they quickly returned to salvage the hotel after a particularly unsuccessful manager wreaked havoc.

> *Mrs. J.I., Hale has assumed possession of the Zang hotel under lease and took charge of the house the first of the week.*

> *Mr. McBrayer, along with the formerly [sic] Mrs. Hale, expects to move into and take possession of the Zang hotel on the third of the month and within a couple of days thereafter reopen the house.*

ZANG HOTEL FOR RENT: Will rent the hotel to good responsible parties for one or two years at reasonable rent. For further particulars see John Zang at the Zang Hotel.

Mr. and Mrs. John Zang, who have been here so long, that the mind of the oldest inhabitant runneth not to the contrary, were departures on Saturday's limited, bound for Hotchkiss, Colorado, where we are given to understand, they have bought into a fine hotel property. Creede will sure hate to lose John and Lizzie Zang, those two optimistic souls, but needs must when the devil drives so looking at it that way, everyone will wish them the utmost of success in their new location. That's where we join in with a hearty "me, too."

Mr. and Mrs. John Zang announce that they will again assume charge of the Zang Hotel on November 1st. They hope that all of their friends and former patrons will remember this fact.

On and after January 1st 1911, I wish to announce that the following rates will be offered local boarders at the Zang Hotel. Room and Board $1.00 per day, Board by the Month $26.00. Meal Tickets $6.00 for 21 Meals. Single Meals 35 cents each. These are the old rates charged by the Zang Hotel in past years and I am content to charge these and reap a small but fair profit. The above rates, I would add, were advanced when I was away from the Hotel and without my consent. John Zang, Proprietor[121]

During their tenure, the Zangs were host to a variety of some of the West's famous persons: Bat Masterson, Soapy Smith, Poker Alice Tubbs, Bob Ford (who shot Jesse James) and Ed Kelly (who shot Ford). John and Lizzie continued to run the Zang Hotel and planned to retire in Creede, until John was killed in June 1911. Lizzie was rocked by his death, but she was able to continue running the hotel until she sold it in September 1921. She remarried and relocated elsewhere. Renamed the Creede Hotel, it had a series of owners, including Maude Russell, affectionately known as "Beartown Maude" (a story for another day). She operated it from 1938 until 1946, when she sold it to Lillian Hargraves. The Hargraves family made major improvements to the hotel, including adding a bar in 1951. They operated the hotel until 1968, when they sold it to the first in a series of owners.[122] The hotel suffered multiple minor fires over the years, but it was always restored. It is now owned and successfully operated by Creede and Madison, LLC.

Mrs. Fannie LeFevre

Not a Shrinking Violet

Michael and Fannie LeFevre had come to Creede as part of the silver rush in the early 1900s. A newspaper article relates the terrifying story of a train wreck, with Michael and Fannie on board. They were on a train coming from Wagon Wheel Gap to Creede on March 22, 1908, when a loaded ore car broke loose in Creede and started hurtling its way down the track. Although the train personnel attempted to alert others down the track, there was no way to contact the passenger train, which had already left the gap. Fortunately, the engineer saw the oncoming car and managed to get his train almost stopped when the collision occurred. The passengers were shaken up, but none were seriously injured.[123]

Michael was a miner and Fannie a housewife. Michael was in his mid-forties, but Fannie was much younger, about thirty and presumably an attractive young woman. Michael was French Canadian and spoke both English and French; however, Fannie's primary language was French, and she spoke little English.

They lived in what was affectionately known as Stringtown, the string of buildings between Creede and the small town up the creek, known as Upper Creede. Michael worked in the mines up the canyon above Stringtown. On the morning of June 11, 1911, Michael left the house to go up to the mines. He rode a white horse along the main (and only) street through Stringtown. Neighbors observed him go, as his white horse was noticeable.

After his shift at the mine, he was met on the road by his disheveled and distraught wife, who informed him that she had killed a man in their

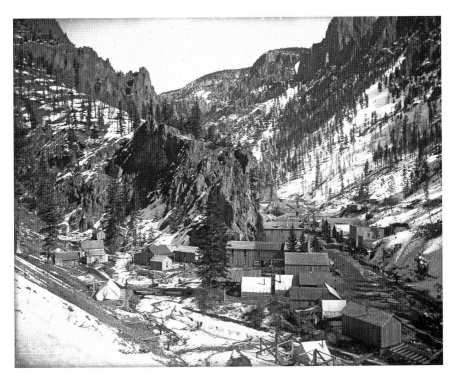

Creede Mining Camp. The Upper Town is seen here circa 1900. *William Henry Jackson Photograph Collection; CHS.J2673, History Colorado.*

house that afternoon. Michael took Fannie back to the house and saw the body. It was about 4:30 in the afternoon. He then went down to Creede to inform Sherriff Duncan of the event. The two men left to go to the house, along with two men from the district attorney's office and the newspaper editor. Creede's early history was that of a rough-and-tumble town, even for a mining camp, with plenty of serious crime. But in recent years, things had calmed down as Creede grew and became more stable and respectable. Therefore, news of a murder in town made headlines in newspapers across the state.

> *And men move on, and give no heed*
> *To life or death, and this is Creede.*[124]

Once the men had investigated the scene and contacted the coroner to remove the body, Fannie LeFevre was taken into custody and remanded to the Creede City Jail on Sunday evening. The next morning, a coroner's

inquest was held to determine the path forward, when Fannie gave some startling testimony. In her halting English, and with some assistance from a French-English interpreter, she was able to relate to the inquest panel what had happened. She showed much emotion in her hesitant recital of the struggle with the deceased.

On the afternoon in question, Mr. John Zang, proprietor of the local Zang hotel and prominent businessman in Creede for many years, went to the LeFevre home and found Michael away. When he discovered the husband was absent, he attempted to embrace Fannie. She repulsed him and warned him to desist. She declared that she had been pushed into the bedroom, her clothing torn and hit in the face. She stated that she fought as long as she could. After being thrown on the bed three times and after a desperate struggle, she broke away from him and ran into the kitchen, seizing her husband's revolver. Pointing the gun at John, Fannie ordered him to leave the house. But he refused and struck her in the face with his fist. She again threatened him with the gun, and the man struck her again. This time, Fannie pulled the trigger; a bullet struck John in the head, killing him instantly. The time of death was estimated to be about 3:00 p.m. Fannie ran from the house and started up the road to find her husband.[125]

Hearing this testimony, observing her battered countenance and considering some corroborating evidence from neighbors, authorities determined that Fannie acted in self-defense. She was acquitted of all charges and released into her husband's care. Although innocent of any wrongdoing, Fannie was nevertheless traumatized by the event and never recovered her health. A couple of years later, she and Michael were walking in Creede when she said she felt ill and sat down on the sidewalk. Although the doctor arrived almost immediately, Fannie died moments later. It was October 17, 1914, and she was thirty-four years old.[126]

A funeral for John Zang was held in Creede. After it was released by the undertaker, Lizzie took the body to Denver to be buried in the Riverside Cemetery, on June 14, 1911. John Zang was sixty years old at the time of his death. Michael LeFevre remained in Creede and died in the flu epidemic of 1918.

Oppy, Early-day "Prepper"

O ppy had been a private in the U.S. Army, D Company, Fifteenth Field Artillery Regiment in World War I. The regiment utilized 75-millimeter howitzers, which were credited with winning the war. But they were also likely the reason Oppy returned to civilian life in a condition that was at the time referred to as "shell-shocked."

After the war, Oppy mined copper in South America and gold in Alaska. In the spring of 1928, at the age of forty-two, he arrived in Mineral County, looking for a suitable place to settle down. Finding the people and country of the Upper Rio Grande to his liking, he called Creede home. He found work as a blacksmith in the mines around Creede, where such talent was always in demand.

Born in Kansas on August 22, 1886, Oppy's given name was Louis Chester Brechman. He was adopted by a devout Seventh-day Adventist family named Oppy when he was seven. He insisted on being called simply "Oppy," and he signed legal documents "L.C. Oppy." Shortly after joining his new family, they moved to Cripple Creek, Colorado, and he was on his way to a life of mining and prospecting in this booming town. Thousands of prospectors flocked to the region between 1890 and 1910.

The unfortunate experience of being shell-shocked in France during the war had left Oppy prone to sudden anger, suspicions and eccentricities. Realizing this, he chose a life alone. However, when the mood struck, he made extended visits to friends. Because of his world travels and wide range of reading subjects, he was an entertaining and desirable guest. Chopping

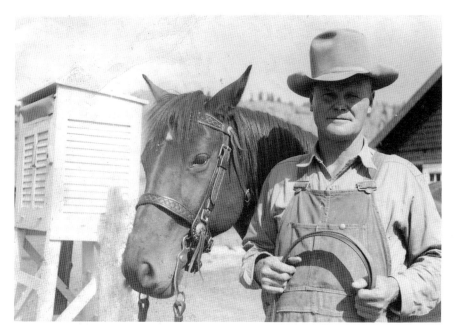

Photo of Oppy, circa 1940. *Author collection.*

wood and doing chores in trade for room and board, Oppy was especially careful to do odd jobs for the lady of the house "that had been wanting done for ages," thus ensuring him another welcome. He was a talented carpenter and assisted ranches with small and large carpentry jobs.

Because of his damaged psyche from the war, Oppy received a government pension, which, along with an occasional grub-stake from a local rancher, enabled him to spend the summers prospecting and tramping the Rio Grande, Ute Creek, Trout Creek and Red Mountain areas. A snug cabin, hidden in the timber, awaited him in each area he frequented. However, prospecting had to bide its time, when in the summer the rhubarb patch at Ruby Lakes was ripe. Then Oppy encamped in the "dug-out" cabin at Ruby, harvesting and canning his favorite food, which he backpacked out to enjoy in the winter. He kept a large pot and jars at the cabin, which had a wood stove. Rhubarb was a precious commodity to early miners and explorers, providing vitamins C and K and several minerals.

Oppy built miniature cabins throughout the area, where he stored food. Flour, sugar, beans, macaroni and coffee were kept in vermin- and weather-proof containers. About six feet by eight feet, with dirt floors, packed earth roofs and room for a bunk, they were nothing fancy, but they offered shelter

Oppy's cabin on Trout Creek is seen here, circa 1960. *Author collection.*

for a night. These were used primarily as relay stations for his food caches. One was located on the outlet to Lost Lakes; another was about two miles up the trail across the Rio Grande toward Ute Creek; and another was up in Ute Creek itself. These small cabins were constructed in the 1930s, during the Depression, when foodstuffs were precious. He was worried about Russia invading the country and what the people of the country would have to do to fight them. Oppy was sure that sometime in his lifetime the United States would be attacked by the "Russkies," as he called the Russians. These cabins were places for his close friends to hide and have food while evading the Russkies. Oppy also used the cabins as shelter while he wandered the high country to prospect. He assumed that the attacks would be in the summer, since there was so much snow in the winter.

He appropriated three larger preexisting cabins for his use, stocking them with food and cooking gear. One was on the middle fork of Trout Creek; another, built by Clayton Wetherill, was at Ruby Lake; and another, built by the mining company that had previously worked there, was at the sulfur beds. Oppy fixed up the cabins, put canvas roofs on those that had no roof and made them habitable. The cabins were small, about eight feet by ten feet.

Oppy was prospecting at every opportunity. He returned with some good gold ore, but he would not tell anyone where he found it. One time, he agreed to show Charlie Kipp and Carroll Wetherill where his mine was on Red Mountain. They were to depart from the Wetherill ranch and were getting packed up to go when one or the other of the men said something that annoyed Oppy, who took off walking to Creede. The two men followed Oppy in vehicles, but he refused to return with them and stayed mad for some time. He never showed them or anyone else where his mine was. However, he was never rich from his ore finds.

His religious upbringing proved a good influence on him. While sometimes uneven of temper, Oppy was a genuinely good person. Preferring his good deeds to be recorded in "the Book," as he said, rather than in the minds of men, many of his kindnesses went unknown. Family stories relate that in the Depression years, Oppy regularly backpacked fresh elk and deer meat he had killed in the forest (probably illegally) into Creede at night, leaving a quarter portion of the game here and there, at homes of widows and large families. Oppy most likely never purchased a piece of meat in his life, as he was an accomplished hunter. Chances are that the game warden in the area knew about his poaching, but also knew that Oppy was helping needy families, and so turned a blind eye to his activities. Oppy's religious upbringing also made him an expert on the Bible. It was said he could "out-Bible" any preacher man. He loved to discourse with the local clergymen and was well regarded.

Oppy knew how to drive a vehicle, but he chose not to own one. When he was helping around the farms and ranches, he was more than capable of driving, but he did not want to own a vehicle. He would ask people for rides if he wanted to go somewhere farther than he could easily walk. Often, he would just take off walking. With his long stride, he could cover the ground at a speed of four miles an hour. He also did not own a horse, but sometimes would borrow a horse if he had a long way to go in the mountains. Many of his acquaintances were happy to lend him a horse, as the payback was always to their benefit. Carroll Wetherill kept a horse named Oppy that he always lent to him, since it was good about staying with him in camp by itself. Eugenia Wetherill at Wetherill ranch was more than happy to loan a horse in exchange for his services around the property, and Emma McCrone at Soward's ranch did the same.

When not in the mountains, Oppy lived in a couple of locations around Creede, but an old cabin near the confluence of East and West Willow Creeks was his home for several years and is often referred to as

Oppy's cabin is seen here in a photo taken in 1989. Note the Christmas lights. *The Denver Public Library, Western History Collection, AUR-839.*

"Oppy's place." Originating from the very early days of Creede, it is still standing today.

Gene McClure, one of Oppy's good friends, owned Tompkins hardware store in Creede. For years, when Oppy went into the store, he always gave his pistol to Gene to keep in the safe while he shopped, and he would retrieve it once he had completed his shopping. This went on for many years, but when Gene was killed in a head-on car crash, Oppy would not give his gun to the new clerk, instead keeping it in his backpack. The loss of Gene seemed to unhinge Oppy, even more than usual, and at about this same time he started to think he had not been receiving his pension checks. One day in the summer of 1967, the same year Gene was killed, Oppy left the hardware store and went across the street to the hotel restaurant and found District Judge Martha Nelson having her lunch. He walked over to her table, sat down across from her, pulled his pistol out of his backpack and pointed it at her. He said, "If you don't give me my pension check, I will shoot you in your big, fat belly." Judge Nelson, who was a large woman, calmed him down and contacted the sheriff. Oppy was taken in, and matters were arranged for his removal to the Fort Lyon Veterans Affairs Hospital in Bent County, Colorado.

Oppy was well known and well liked in Creede and the general area, so everything was done gently and carefully. But, he had become a danger to others, and that was just not an acceptable situation—even in Creede. Fort Lyons Veterans Affairs Hospital became Oppy's home for the remaining days of his life. He died about a year later, on August 31, 1968, and was buried on September 5, 1968, in the Fort Lyons National Cemetery in Bent County. He was eighty-two years old.

Oppy could outwalk a horse and out-Bible a preaching man. His cussedness was classic and his kindness was concealed. He remains a legend on the Upper Rio Grande.

Quentin Roosevelt Visits the Upper Rio Grande

O n August 14, 1909, Teddy Roosevelt and his guide, John Wetherill, along with Navajo and Paiute guides, traveled through the rugged desert Southwest to Rainbow Bridge.[127] The publicity caused by this trip resulted in the site being designated a national monument in 1910 by President Taft. Always an adventurer and hunter, Roosevelt in the ensuing years made several trips to the Southwest with Wetherill, from the Wetherill Trading Post in Kayenta, Arizona. Sometimes, one or more of the four Roosevelt boys would accompany their father, and those who did not would hear the fantastic tales when the hunting party returned. Quentin, being the youngest child, heard many stories from his father's and brothers' trips. John Wetherill's son, Benjamin Wade, was the same age as Quentin, and the two young men became close friends, meeting during previous Roosevelt trips to the desert Southwest.

In 1915, the two eighteen-year-old boys—Quentin Roosevelt and Ben Wetherill—planned a grand bear-hunting trip in the southwestern mountains of Colorado. This was Quentin's first solo trip to the desert Southwest, and he faithfully corresponded with his mother both before and after the trip. Quentin traveled on the train to Gallup, New Mexico, where he was to meet Ben and travel to Kayenta, Arizona, to start the hunting trip. The planned trip would take several weeks and cover many miles, up through southwestern Colorado, along the Florida River in what is now the Weminuche Wilderness and over into the Creede area. The boys would stop to see Clayton Wetherill, John's brother and Ben's uncle,

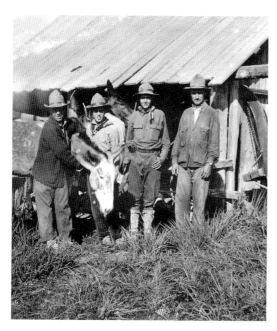

Quentin Roosevelt (in light-colored shirt) at Clayton Wetherill's Hatchery outside of Creede, circa 1913. *Author collection.*

whom Quentin knew from previous trips.

In a letter to his mother written from Gallup on Saturday, July 11, 1915, Quentin tells her of his already adventurous trip and that he was leaving the next day to Kayenta and the Wetherill Trading Post, a four-day ride from Gallup. There were problems with a cloudburst flooding the tracks, and the train was delayed. Arriving in Gallup, he did not find Ben, or anyone else he knew.

Finally, I found an Uncle of Ben's [probably Uncle Alfred Wetherill, the Gallup postmaster] *who said that Ben had telegraphed me when I was coming and that I had not answered. He was probably still at Kayenta. That was unfortunate, but I arranged to have an answer sent out there from here to tell him. Kayenta, Mr. Wetherill's place is about four days' ride from here. I very nearly left myself on the road, seventy-five miles from Kayenta. However, if I did that I might pass Ben without meeting him, and there he would be in Gallup and I would be in Chinle* [near Kayenta]. *Deplorable state of affairs.*[128]

Ben, of course, arrived shortly, and the group departed to Kayenta and the Wetherill Trading Post. There they found many others gearing up to go on various adventures. However, the bear-hunting party was small. Although young, Ben had guided and hunted with his famous father, John Wetherill, and with his uncle Clayton Wetherill for many years. The two young men with their pack mules and a couple of camp helpers took off, looking forward to good bear hunting and fishing.

The young men, out for an adventure on their own, pushed the horses and pack mules hard and traversed some very rough country. Quentin was

surprised to find snow in the middle of summer at the high elevations above timberline. There is no record of any bears being killed, but one of the pack mules took a bad fall over a cliff, although he was able to walk away. The small party came over Weminuche Pass and down the Rio Grande toward Clayton Wetherill's place, as their animals were spent. Arriving at Uncle Clayt's place, the boys got a dressing down about the deplorable condition of the animals. Their plans were then changed, as detailed in Quentin's letter to his mother dated August 18, 1915.

> *The long and short of it was that we decided to stay over there and that I would take the train from Creede in a couple of weeks. When the animals were recovered, Ben would take them back to Kayenta. The stock was so poor that there did not seem to be very much chance of our making Gallup, at least not without it being very hard on them. Ben's Uncle, who has been a guide for the past 20 odd years said that we would not be able to make Gallup by the 10th of September without killing our horses. He gave Ben an awful blowing up for the way we started out, he said that the pushing we did in the first three days was what did for our horses, and he was right.* [129]

Not wishing to cut his trip short, Quentin remained with "Uncle Clayt," hunting and fishing in the area, guided by Clayton and Clayton's brother-in-law Theodore Faunce. Ben was around for a while, and when the animals recovered, he left to return to Kayenta. Quentin, being a good sport, was glad to help out with chores and other duties. Clayton wanted to build a dugout on his property at Ruby Lakes, and he took both brother-in-law Theodore Faunce and Quentin Roosevelt up with him to make the structure. He also took the same little crew over to Charlie Mason's place at Hermit Lakes to build a new barn. Quentin was glad to be part of the crew and work alongside them. However, he also took advantage of his local fishing experts and guides, as he relates to his mother in the same August 18 letter.

> *We had some wonderful fishing, and I think my luck must have turned, for I caught one that weighed three and ¼ pounds. It was the best sport in fishing that I have ever struck. We went all over the country 'round there. My but those mountains are wonderful. Creeks and streams and waterfalls all over the place.* [130]

On the appointed day, Quentin was taken to Creede to catch the local train to Gallup (with which he was not impressed) and from there return to

Long Island. Quentin had to be back to attend a military aviation training camp with his brothers and then attend to his university studies. However, the war intervened, and in May 1917—less than two years after his Colorado adventure—Quentin joined the First Reserve Aero Squadron and was a fighter pilot with the Ninety-Fifth "Kicking Mule" Aero Squadron in World War I. Unfortunately, the sad ending to this story is that just a year later, on July 14, 1918, he was killed in action. Quentin was shot down by a German Fokker plane over the Marne River in France. He was just twenty years old.

Theodore Roosevelt and his wife, Edith, were at Sagamore Hill on Long Island when an Associated Press reporter sought them out on July 17 and asked for a statement on their son's death. TR said only, "Quentin's mother and I are very glad that he got to the front and had a chance to render some service to his country and show the stuff that was in him before his fate befell him." The grief-stricken former president died in his sleep less than six months later.[131]

At least Quentin had been able to experience and enjoy the beauty of the Upper Rio Grande in his short life.

FRANKLIN/GALLOWAY RANCH

Harry Franklin, a twenty-five-year-old Englishman, moved to Antelope Park and established what came to be known as the Franklin ranch about 1871. He visited his native Reading, in Berkshire, England, in the winter of 1873–74 and returned to his ranch in April 1874. Franklin remained with his ranching business for a couple more years and served as Hinsdale County assessor and commissioner.[132]

Hinsdale County deputy clerk and recorder Henry H. Wilcox was a tenant on the Franklin ranch in 1874–75. He was the husband of Harriet Wilcox, and the couple had three children. Henry and Harriet were originally from England, where Henry wished to pursue a scholarly life as a minster in the Church of England. They had moved to the United States to be with her family back East, then Harriet convinced him to move the family out West. Henry went along and tried to make a go of things, but he was miserable and soon started drinking, eventually leaving the area late in 1875. Harriet applied for and received a final divorce, citing abandonment, in 1876. She married local rancher Martin van Buren Wason on November 20, 1877.[133]

It was in the early spring of 1876 that the Franklin ranch was acquired by James Perkins "J.P." Galloway. After selling the Antelope Park ranch, Harry Franklin moved across the divide and found a good life as a rancher. However, on one trip, he traveled to Silverton on his way to the Durango Fair. Unfortunately, Harry and his new friends imbibed a bit too much. In the ensuing brawl, Harry was knifed, but he survived to tell the tale.[134]

Harry eventually got married and settled down, but his heart remained in the Upper Rio Grande. The twenty-second annual meeting of the Pioneers of the San Juans was held in Del Norte, as related in the October 7, 1916 edition of the *San Juan Prospector*. Harry and his wife led the procession of San Juan Trailblazers representing the year 1871.

Born on September 6, 1839, in St. Louis, Galloway had married Minerva Caroline Wade in Illinois on August 1, 1860. They had seven children. He died on February 28, 1897, and she died on July 27, 1915. Galloway had fought for the Union as part of the Second Missouri Cavalry. Following the war, he became a U.S. marshal in Missouri connected with the revenue department. Galloway was meeting with other members of the revenue board of registration when a mob, unhappy with the course of Reconstruction, stormed the courthouse in Palmyra, Missouri. Galloway killed one of the mob and was jailed and indicted for murder by the grand jury. He was ultimately discharged, but it was clear that he could no longer live in the land that he thought would be his home. So, he packed his family, which by now consisted of three sons and two daughters, into a covered wagon and headed to Colorado. It was part of a general family migration. His father, Gideon, and brother Harrison, who had married Minerva Wade's sister, were both printers in search of new fields. Gideon and Harrison ended up associated with the Pueblo *Daily Chieftain* for many years, but James did not stop until he saw the lush greenery of Antelope Park. He took up a small spread, then took advantage of the opportunity to acquire the Franklin ranch in 1876.[135]

Galloway, an entrepreneur, rapidly grew his freighting and stock business, allowing nearby San Juan City to retain the food and lodging enterprise, and the two operations coexisted for several years. James Galloway's freight station expanded to cover an estimated four acres at its height. During the first season, over half a million pounds of freight passed through the station. Both freight and mail were often left there by the original transporter, and Galloway issued a printed receipt for all materials accepted. Galloway and the experienced men working for him were able to deliver much of the material to its intended destination, thus enhancing his reputation.[136]

The forwarding and commission establishment at Antelope Park was as far as most wagons could move up the Rio Grande route to Silverton up to the end of 1879. Galloway's freight business remained lucrative until 1882, when the railroad arrived in Silverton and traffic along the Rio Grande route dried up. However, until that time, Galloway was a resourceful

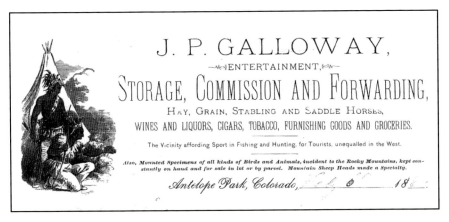

Galloway freight receipt, 1876. *San Juan County Historical Society.*

J.P. Galloway advertisement poster, February 6, 1883. *Courtesy Hinsdale County Museum, Lake City, Colorado.*

entrepreneur and was involved in all sorts of activities to entice travelers with money to spend.

> *Some weeks ago, some horses belonging to Mr. James Galloway, of Antelope Park, were stolen. Jim pursued the thieves, captured one of them and the scoundrel, trying to escape, was shot dead by his captor. Jim reported the case to the coroner who held an inquest and acquitted him of all blame.*[137]

As his reputation for being tough and fair grew, Galloway was convinced by friends to run for public office. He ran for Hinsdale County sheriff and lost; it was not to be his last political contest in the San Juans. In 1882, he successfully ran for Colorado senate representing Rio Grande, Hinsdale and Gunnison Counties. He served until 1886, when he felt that the burden and "abuse" of the job was too much, although he was highly regarded by his constituents.

No more honorable gentleman sits in the senate than James P. Galloway. Possessed of a high order of ability he is an honor to the San Juan—and to the state.[138]

Galloway, after being elected in 1882, received his patent for the 160-acre Galloway ranch in Antelope Park, Hinsdale County, in March 1883—just prior to selling it. He transferred his ranching operation to the Paradox Valley near Bedrock, Colorado. He operated a highly successful ranching business and supported his sons in mining and exploration.

Senator James Galloway is said to be one of the heaviest stock raisers in the West.

Ex-Senator James P. Galloway confirms the report of the recent important gold discoveries in the Navajo-basin, San Miguel county, a big strike having been made in the Sweetheart mine operated by his sons, Wood, John and Gordon and James and their cousin. The strike was made last week when the Sweetheart operators got an eighteen-inch streak of tellurium that runs most satisfactory.[139]

The San Juan Post Office was established at San Juan City in 1874 and operated by Clarence Brooks. As Brooks's other interests grew, he no longer wanted the operation, and it was transferred three miles down the road to Galloway's on May 16, 1877. Galloway took over operation of the relocated post office and ran it for several years. After the departure of Galloway in the spring of 1883, the San Juan post office (at the Franklin/Galloway ranch) was taken over by Jacob J. Abbott on July 23, 1883. He was succeeded by James H. Holmes on August 20, 1884; Herbert Bent on May 21, 1894; and Anna Wright on July 5, 1922. The post office was discontinued on March 8, 1923.[140]

The San Juan Post Office at San Juan City operated for barely three years; it then operated for almost forty-five years at the Franklin/Galloway ranch. It was common for post offices to move while retaining the same name, as small towns often disintegrated and were not able to support the operation. However, the use of the same name at different locations is a source of confusion for later historians.

The property was purchased from Galloway by J.J. and J.W. Abbott, who sold to the Bent family and they sold it to Lora S. Officer in 1905.

James P. Galloway, circa 1883. *San Juan County Historical Society.*

Officer, who owned the ranch for fifty-five years, developed the property for its tourist and ranching opportunities, and the location became locally known as "Officer's." Charles Dabney purchased the ranch from the Officer family after Lora's death in 1960, expanding the tourist and ranching business and removing Galloway's old stage stop buildings. The current owners are David and Peggy Strate, who renamed the property San Juan Ranch and operate a popular tourist resort. In addition, they lease their lush grass pastures to cattlemen of the San Luis Valley—continuing the ranching tradition established by Harry Franklin in 1871.

SAN JUAN CITY

First County Seat of Hinsdale County

The San Juan Town Company was incorporated on December 6, 1873, in Conejos County, in the Territory of Colorado. Six trustees were appointed: W.H. Green, Benjamin D. Spencer, Edwin A. Reser, James H. Lester, Alba R. Thomson and Daniel Witter, president. The company was formed "for the purpose of aiding, encouraging and inducing immigration to the Territory of Colorado to aid generally in promoting the country and to establish, lay-out and build-up of a town [called San Juan City] on the Rio Grande River in the County of Conejos in the Territory of Colorado."[141]

Little-known Denver pioneer Daniel Witter, who owned considerable real estate near the city, had an abstract office and was the federal tax assessor. Daniel's wife was the sister of Schuyler Colfax, vice president under Ulysses S. Grant from March 4, 1869, to March 4, 1873. Colfax Avenue in Denver is named after Schuyler. Daniel was among those who had visions of making something of the short-lived San Juan City on the Rio Grande. As president of the San Juan Town Company, he signed the special warranty deeds to sell the lots and blocks of the proposed town site of over 150 city blocks.

Captain W.H. Green had been active in the southern San Juan area mines for a couple of years and was a major supporter of the new city. He purchased numerous blocks and lots of the new town on February 19, 1874, as did other trustees. He and others built a handful of cabins and erected some tents at the town site. Green also served as the first Hinsdale County clerk and recorder, with Henry H. Wilcox from neighboring Franklin ranch as his deputy.

Captain Green has got a "big thing" in the San Juan country and proposes to go back there in the spring.

San Juan City is the name of a new town sixty miles west of Del Norte in Antelope Park on the headwaters of the Rio Grande. The park is at the confluence of seven mountain streams, and is described as a most beautiful and delightful place. It will claim a large share of the trade of the mines.

The Pueblo Chieftain is informed that on the first of February the stage company will put on a daily line of coaches from Pueblo to Del Norte and San Juan City. The through fare from Denver to Del Norte will be about $30, and to San Juan City, $40.

Capt. W.H. Green left for San Juan City on Tuesday, to look after his interests in the mines.[142]

The Territory of Colorado, an organized and incorporated territory of the United States, existed from February 28, 1861, until August 1, 1876, when it was admitted to the Union as a state. On February 19, 1874, Hinsdale County was created out of parts of Lake, Costilla and Conejos Counties, with San Juan City in central Hinsdale County near the Rio Grande Valley designated the provisional county seat. Captain Green's larger cabin was used as the courthouse.

Mill, James and Co., proprietors of the Pueblo, Del Norte and San Juan Stage line, have put on a line of stages to run from Del Norte to San Juan City, sixty miles from Del Norte, and 40 miles from the mines. At San Juan City, the stage will connect with a pony express, which they have just started. It will carry mail and express matter; the postage on letters has been fixed by the department at ten cents.

A new town, to be called San Juan City, has been laid out in Antelope Park, and lots are selling briskly.

The Tribune says: Acting Governor Jenkins, this morning, made the following appointments for Hinsdale county—one of the new counties in the San Luis Valley: W.M. McCree, county surveyor; Edward Wood, constable; F.H. Davenport, county treasurer; and Harry Franklin, county assessor. The Hon. D.C. Russell, of Del Norte, who was recently appointed

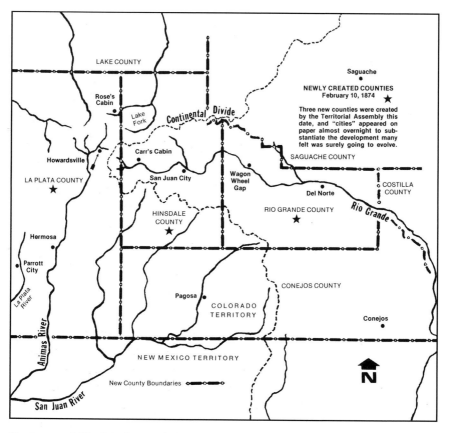

Newly created Hinsdale County, Colorado, is seen here in 1874. Note: Mineral County was not created until 1893; it lies between Hinsdale and Rio Grande Counties. Many More Mountains, Vol. 1: Silverton's Roots. *Allen Nossaman.*

probate judge of Hinsdale county, declined the appointment on account of private business. The acting governor will make a new appointment in a few days.

Hinsdale County Coroner appeared before Justice of the Peace Orlando A. Mesler at San Juan City, the provisional seat of Hinsdale County, and obtained a warrant for the arrest of [Alferd] *Packer "dead or alive" that was directed to the sheriff of the county.*[143]

Despite the best efforts of enthusiastic city developers and miners, San Juan City had a short life. By the following year, it was decided that the county seat should be moved over to Lake City, where mining had developed

the area more substantially than over the pass at San Juan City. Therefore, early in 1875, just about two years after the incorporation of San Juan City, everything was packed up and moved to what became the permanent location of the Hinsdale County seat at Lake City. Most of the original residents of San Juan City followed the move to Lake City. San Juan City, not much more than a few cabins and tents anyway, experienced a rapid decline after February 1875. The settlement never grew into a city or even a town, due to its relative isolation from major mining centers.

San Juan City, the county seat of Hinsdale County, which sprouted in Antelope Park last summer, has been loaded into wagons and moved over into Lake Mining District, some thirty or forty miles. The Sheriff, Probate Judge, Justice of the Peace, etc., have all gone, too. Taking the books, dockets, and all the papers appertaining to the county.

W.H. Green is clerk and Recorder of Hinsdale County.[144]

Warranty deeds from the Hinsdale County courthouse document the sale of justice of the peace A.O. Mesler's property in San Juan City to Anna Taft, as the Tafts remained to run the post office. Mesler had moved over to Lake City. The first half was sold in February 1875, the same time the courthouse was moved, and the second half was sold that April. The documents were signed by W.H. Green, Hinsdale County clerk and recorder, and Henry H. Wilcox, deputy recorder. Other county government positions fluctuated between the relatively few local men.

The Prospector has the following nominations for County officials of Hinsdale County: County Commissioners: Harry Franklin; W. Bryan and B.A. Taft
County Clerk: A.O. Mesler
Sheriff: Jim Sweeney
Probate Judge: W.H. Green
Assessor: W.F. Ryan
Treasurer: B.L. Jones
Surveyor William McCree
School Superintendent: H. Wilcox[145]

The San Juan Post Office was established on June 24, 1874, with Anna Taft as postmistress, at San Juan City. She ran the post office until June

21, 1875, when she and her husband, Ben, moved to Silverton to establish a drugstore. While both the establishment and the marriage struggled, the former survived. The marriage did not. As was common for legal and financial reasons at the time, the business was initially conducted in the wife's name, and references to Anna Taft, druggist, are numerous. Her husband was the proprietor. On June 15, 1876, Anna Taft confessed to her husband that she was "enticed by another man," and she left about a week later and never set foot in Silverton again. Ben waited but eventually filed for divorce in October 1879. He carried on the business in Silverton for nearly thirty more years.[146]

Statewide interest in the riches to be found in the San Juans, a remote and isolated region of Colorado, inspired newspapermen from the more densely populated Front Range of Colorado to take it upon themselves to make the trip and write about the journey. As the town of Pueblo was the point of embarkation into the San Luis Valley and on into the San Juan Mountains, the challenge was issued to these men to take the arduous trip. Travel was a series of various horse-drawn conveyances and, finally, on horse or mule. From these travelogues, it is possible to get a glimpse into life on the roads in these early days, specifically in the town of San Juan City.

During 1875, newly married Clarence and Swedish-born Ada "Dollie" Brooks moved to San Juan City, where they built a "substantial stone building" that was used as a post office and hotel/restaurant. It still stands today. Brooks assumed the role of postmaster on June 22, 1875, after Anna Taft's departure. He also purchased her San Juan City property, which he shortly sold to Ada. Brooks was to become the primary entrepreneur of the essentially defunct San Juan City. According to the *Colorado Chieftan* of September 4, 1875, the station provided the "comforts and conveniences of well-established, older stations."

The Rio Grande winds along its western border, and Clear Creek, half as large, cuts it in two at right angles. The mountains on the south are heavily timbered and slope gradually down to the grassy level, while some of their old bald heads are thrust up two thousand feet above the line of vegetation. On the opposite side a row of foothills, surmounted by a palisade-like cliff half encircles it, while the river runs with a silvery sheen its entire length from west to east. Near where the road crosses Clear Creek, a half dozen abandoned log cabins stand. They were once honored with the title of San Juan City. C.W. Brooks has erected a substantial stone building at this place, where a post office has been established and supplied with semi-

weekly mail from Del Norte. Those who have occasion to test Mr. and Mrs. Brooks hospitality will not regret it. Many of the comforts and conveniences of well-established and older stations are to be met with here.[147]

The San Juan mining fever continued unabated, and another correspondent of the Pueblo newspaper, which had done an article in 1875, followed up with a trip to the mines at Silverton two years later. The story is joined at Alden's Junction, where the stage route divided to go west to Lake City and south toward Silverton. San Juan City is no longer acknowledged in the article, but Brooks is, along with his ranch and stopping place. The general area of this section of the Rio Grande became known as Antelope Park, from nearby Antelope Springs, and several ranches in the area are said to be included in Antelope Park. However, the animals who loaned their name also gave their lives and are no longer found in this area. The other major locations are identified as "J.P. Galloway commission and forwarding house" two (or three) miles from Brooks' site, and Lost Trail Station farther on. In 1876, Galloway took over the Franklin ranch, and Barber established a new stage stop at Lost Trail Station in early 1877.

Antelope Springs or Alden Junction [modern-day Broken Arrow ranch] *is sixty miles from Del Norte, and is the junction of the roads from Silverton fifty miles west and Lake City thirty-five miles northwest. Its altitude is 8,500 feet, and Clear Creek unites with the Rio Grande a few miles further west. Mr. Alden is among the pioneers of the country and thoroughly posted in its business developments and mineral resources. The principal stops on the road to Silverton are San Juan City* [modern-day location of Freemon's Ranch], *6 miles, where C.W. Brooks keeps a ranch and stopping place. At Antelope Park* [modern-day San Juan Ranch], *8 miles, J.P. Galloway has a commission and forwarding house, where freight generally is transferred from wagons to pack trains. At Lost Trail, 25 miles, J.T. Barber has a storage and commission house, and at Carr's Cabin all goods break bulk. Joel Brewster presides over the stopping place here. Mr. W.M. Wilson carries the mail tri-weekly from Antelope Springs to Silverton; a two-horse hack is used as far as Carr's Cabin, and from there pack animals are substituted.*[148]

However, not all journeys from Del Norte to Silverton were successful or enjoyable. According to Peter Silva's poem, written in the Silverton jail in 1878, he borrowed a mule from Clarence Brooks at San Juan City, rode over

Stony Pass, down through Cunningham Gulch and on to Silverton. Arriving in Silverton, he was riding down the street when the mule's real owner, who had left his animal with Brooks to be pastured, recognized the apparently stolen animal and had the innocent man arrested. After his eventual release from jail, Silva supposedly stayed in Silverton, making a living for many years as a janitor in the local saloons.

> *Go west, Old man, I heard 'em say, so full of hope I took my way, determined I would go as far as I could ride on a railroad car. But, when I got to Fort Garland, I found my journey just begun. The west was still beyond I found, and "Westward Ho" the stage was bound. Or, sage and alkali it went, and on I sped with good intent. Until alack, my cash gave out, and I by force was compelled to walk. With every footpath I must cope, from Wagon Wheel to Antelope, tired and footsore, I came to Brooks, who pitied my dejected looks, and with credit helped me on my journey westward to the San Juans. He grub-staked me and loaned me a mule to ride, but not to go to the other side. To send it back from Barber's Ford, I promised, and I broke my word. To break my faith some demon strange said "Gold!" and off I went on Brook's mule as if hell-bent. But, woe that day in Silverton, just as I thought my fortune won, an officer drew gun and said "that ain't Brook's mule, you old gray-head", so now I will take you both in charge and we to calaboose did barge. Now out of luck, no cash, no friend, and here I am at journey's end. I know I plainly said by looks I would like the chance to damn that Brooks.*
>
> *Moral: All men kind will find their level; San Juan has brought me to the devil. Tempted by silver mines to roam, old men should never leave their home, but if they do, should make a rule never to ride a borrowed mule.*[149]

In what has led to some confusion about the location of San Juan City in later years, Clarence Brooks gave up postmaster duties to energetic neighbor James P. Galloway on May 16, 1877, when the San Juan Post Office was moved down the road to Galloway's place. The use of the name "San Juan Post Office" at both the original San Juan City location and after its move to Galloway Ranch has led to location confusion. This is exacerbated by the fact that the San Juan Post Office was in operation at San Juan City for about three years, and at the Galloway ranch for forty-five years.[150]

> *The San Juan post office has been removed from San Juan City to Galloway's, three miles from the old site.*[151]

The two operations—Brooks's at San Juan City and Galloway's just down the road—coexisted for a few years. Brooks specialized in food and lodging, and Galloway dealt in freighting and stock handling. Sometime between 1876 and 1880, Clarence and Ada had a baby, Hermione, who died as an infant and is buried on a knoll south of the San Juan City site.[152] Clarence and Ada had no more children of record. Merchant Brooks continued to operate both hotel and store at San Juan City until the early 1880s, when he and Ada divorced and Clarence left the area. He was thirty-two, and she was twenty-two, having married at a very young age. After the divorce, Clarence moved over to the western slope, married and pursued activities in various mining towns. He settled in Aspen, where, in 1885, he was the deputy recorder of Pitkin County; a bill from C.W. Brooks was presented to the county for payment in 1889.[153] From there, he followed other mining activities around the country, moving up to Idaho Falls, Idaho, in 1900, and eventually over to Weber, Utah, where he died in 1918 at the age of seventy.

As with the Tafts and many others, the Brookses had put the property in the wife's name, to limit financial and legal issues. However, when they divorced, Ada ended up with the holdings at San Juan City, including the "substantial stone building." She also bought all of Clarence's horses and livestock, making her able to operate a successful ranching operation at the former San Juan City site. There was a flamboyant young cowboy in the area by the name of James Wing. He had done some work for Ada. James, thirty-four, and Ada, twenty-six, were married on January 18, 1885.[154]

James and Ada expanded the successful ranching operation and developed the stone building into an establishment that catered to locals and tourists, providing good food, lodging and, presumably, entertainment. About two years into their marriage, a note in the *San Juan Prospector* of March 26, 1887, stated that a son had been born to Mr. and Mrs. J.L. Wing of Antelope Park. However, the child was not named, is not to be found in later records and is presumed to have died shortly after birth. It is supposed that the unnamed baby boy is buried on the same knoll as his sister. There are no surviving children of record for the Wings. Ada died that fall, on September 12, 1887, possibly as a result of childbirth complications and likely a broken heart after losing another child. She was twenty-nine years old. There are believed to be three graves on that same windswept, rocky knoll; Ada is thought to be buried on the same hill as her two children.

James Wing inherited a significant amount of property and livestock from Ada, with which he was able to continue a successful cattle-ranching operation. Within a couple of years, he sold some property, including the

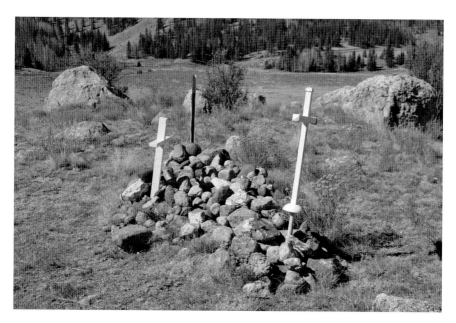

Grave site of Hermione Brooks, Baby Boy Wing and possibly Ada Brooks Wing, photographed in 2016. The white crosses are modern additions. *Author collection.*

"substantial stone building," to a Texas syndicate to be used as a summer resort (later known as the Texas Club). In the fall of that same year, 1890, he married another Swedish-born woman, Clara S. Gustafson. James Wing had filed a homestead patent in 1886. Homestead Certificate No. 681was granted on January 29, 1891, giving the operation another 160 acres directly east of the old San Juan City site.[155]

> *James Wing, the well-known cattle man of Antelope park, with quite a party of his cowboys, was in town this week, the guest of his old friend Oscar Buchholtz.*

> *It is understood that the Wing ranch property at Antelope Park has been sold to a Texas Syndicate for summer resort purposes.*

> *It is not, perhaps, too late to state that Jas. L. Wing, of Antelope Park, and Miss Clara Gustafson of Denver, were married by Justice Franklin, at Wagon Wheel Gap, on Saturday, September 27. They will reside at Antelope Park.*[156]

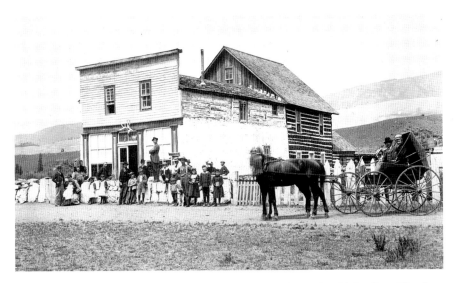

Tourists and visitors at Texas Club, the Brooks' stone building at the old San Juan City site, 1894. *History Colorado, CHS.X4826.*

James and Clara Wing continued to manage the highly popular Texas Club business, which attracted trade from around the area. Clara was a well-known cook, and the food at the club was considered excellent. They had two children: Ester, born in 1892, and Carl, born on August 19, 1893.

> *By horseback or stage it is easy traveling from Jimtown [Creede] to the Texas Clubhouse in four or five hours. Good board and lodging can be had at this house. Mr. and Mrs. J.L. Wing are in charge and take good care of wayfarers.*

> *At the Texas Club, on Clear Creek, arrangements are being made for an unusual number of club members this season.* [157]

James continued the successful ranching operation and was well regarded in that profession. However, the local story relates that James was on a business trip to Pueblo and was gambling and drinking. He ended up in a fight and was fatally stabbed in an alley, leaving Clara a thirty-two-year-old widow with a babe in arms and a toddler. James Workman, a local rancher and neighbor, soon came to the rescue and married Clara in the fall of 1894. James and Clara raised the two Wing children and two of their own, and by all accounts had a happy marriage. The Workmans eventually purchased

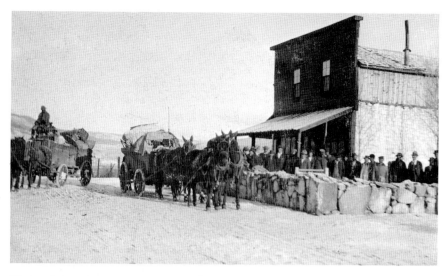

Workers from the Santa Maria Dam stopping at the Texas Club, the Brooks' stone building at the old San Juan City site, November 16, 1911. *Courtesy of the Creede Historical Society.*

the Texas Club from the Texas syndicate and continued running it. Rancher James Workman wanted more grazing land and filed a homestead claim for another 160 acres adjoining the original San Juan City site. Homestead Certificate No. 994 was issued on May 22, 1895.[158]

Jim Workman, of Antelope Park, brought a bunch of fine horses last week and disposed of them at good figures.

James Workman and Miss [really Mrs.] Clara Wing were married Wednesday morning by Sam Nott Hyde, justice of the peace for Spar precinct.

Mrs. James Workman at the Texas clubhouse, made a trip to Creede last week for the purpose of placing her daughter in school there.[159]

In 1906, a telephone line was installed in the Texas Club. A new bridge was put across Clear Creek in front of the club in 1920. The location served as a tourist and resort spot for both locals and travelers. After Jim's death in 1939, and Clara's shortly thereafter, their son Tom sold the operation to Elsie and Gil Traveler, who had been employed by the Workmans. Floyd and Fleta Freemon then purchased the property and sold the old Texas Club

This is a 2016 photo of the Brooks' stone building at San Juan City, now Freemon's guest ranch. *Author collection.*

facility to Ken and Kathy Ellison in 1968, who retained the Freemon name for the ranch. The current operation of the Freemons' guest ranch and General Store—where the best burger in Colorado can be found—continues 140 years of the Brooks's tradition of good food and accommodation for travelers at San Juan City.

The Shade of the Upper Rio Grande

M e? I'm the shade of the Upper Rio Grande, that breathtaking section of the Rocky Mountains from the top of Stony Pass down to the meandering grassy valleys around Del Norte, Colorado.

I've seen the glaciers and ice fields come and go, the up-thrust of the mountains and the creation of the roaring rivers. Slowly animals came, although different ones than I see today. The grazing animals created and followed trails through the meadows and passes. The animals slowly changed to what appear today. Sometime later, I started to see a different kind of animal, one with two legs. This new animal followed the trails the other ones made, and then killed them. These new animals also made fires and only came in summer, dressed in the skins of other animals. Since I have been listening, the word for these new animals is apparently *human*. "Native Americans," they were called.

Sometime after the arrival of the humans walking on their own feet, I started to see some other types of humans. These wore different coverings, and they sometimes rode on other animals. These humans followed the old trails and seemed less interested in hunting other animals, but rather in digging something out of the ground. Once these humans found whatever they were looking for in the ground, they grew excited. This caused many more of these humans to come. "Miners," they were called.

The old paths that had served for so many years were no longer adequate for the new rush of humans. Not only did they ride other animals, but now they had these same animals hooked to contraptions with wheels that

needed wider and smoother paths to travel on. The humans called these "roads." The roads were built to help move what the humans dug out of the ground. The roads mostly followed old trails, but sometimes new roads were made.

It was not that many years until there was no more digging in the ground and most of the humans went away. The roads remained but were not traveled much. The humans started raising other animals in herds on the grassy meadows along the river, bringing them up to the high mountain pastures during the summer. The humans rode one type of animal and chased the others around. "Sheepherders" and "cowboys," they were called.

Then, there was a very noisy and awful contraption that the humans started bringing to my hills—it was called an automobile. It was frail, could not travel any rough road at all and was noisy and smelly, but the humans seemed to love it. The roads that were fine for the earlier contraptions now had to be made very smooth and even for the automobiles. There were few of them around, so it wasn't too bad. The humans who drove these automobiles were called "tourists."

Shortly, there appeared yet another type of contraption, called an "all-terrain vehicle," or "ATV" for short. These contraptions could go just about anywhere and did not need a smooth road. They have now replaced most of the other vehicles I used to see and are even more noisy and smelly. And, there seems to be more of these human tourists getting injured when they ride on these things. Lots of flying contraptions come in to rescue them.

All of this makes me think, with what I have seen in my time on the Upper Rio Grande, what will I see next? Ute Creek, Pole Creek, Long Canyon, Squaw Creek, Long Ridge, Stony Pass, Timber Hill and the Rio Grande River are all human names for some of my many beautiful places. Come see me sometime, I'll be here watching.

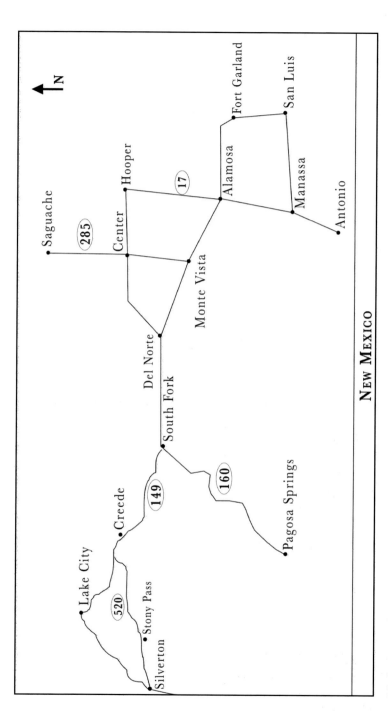

NEW MEXICO

Modern map of the Upper Rio Grande and San Luis Valley. *Map by Cameron Haines.*

Notes

Chapter 1

1. *Creede Candle*, June 4, 1910; May 10, 1913.
2. *San Juan Prospector*, December 4, 1909; *Creede Candle*, December 11, 1909; February 19, 1910; May 7, 1910; June 4, 1910.
3. *Creede Candle*, December 11, 1909.
4. Ibid., May 11, 1912; May 25, 1912.
5. Ibid., June 3, 1911.
6. Ibid., July 8, 1911.
7. Ibid., July 13, 1912; July 27, 1912.
8. Ibid., July 14, 1913.
9. Ibid., March 5, 1910; May 7, 1910.

Chapter 2

10. Wolle, *Stampede to Timberline*.
11. *Gold Run-Silvertip*, June 17, 1893.
12. Ibid., June 24, 1893.
13. Ibid., July 1, 1893.

14. Bauer, Ozment and Willard, *Colorado Post Offices*.

15. Ellis, "Early Day Hinsdale."

16. *Gold Run-Silvertip*, April 18, 1894.

17. Ellis, "Early Day Hinsdale."

18. *Gold Run-Silvertip*, June 17, 1893; June 24, 1893; July 1, 1893.

19. Ibid., July 1, 1893; July 1, 1893.

20. *Gold Run-Silvertip*, April 18, 1894.

21. Bauer, Ozment and Willard, *Colorado Post Offices*; Ellis, "Early Day Hinsdale."

22. *Silverton Standard*, April 20, 1895; October 30, 1897; November 5, 1898; March 18, 1899; May 27, 1899.

23. *Gold Run-Silvertip*, May 16, 1894; *Durango Democrat*, October 28, 1899. (Note: A silvertip can reach a running speed of approximately thirty-five miles per hour.)

24. Colorado Grizzly Project.

25. Traynor, *FDR's Gold Confiscation*.

26. Wolle, *Stampede to Timberline*.

CHAPTER 3

27. *Center Post-Dispatch*, July 14, 1899.

CHAPTER 4

28. Nossaman, *Many More Mountains*, Vol. 1.

29. Ibid.

30. *Colorado Transcript*, April 15, 1868.

31. *Rocky Mountain News*, April 20, 1870.

32. Nossaman, *Many More Mountains*, Vol. 1.

33. *San Juan Prospector*, March 13, 1875.

34. *Denver Daily Times*, March 16, 1875.

35. *Colorado Weekly Chieftain*, March 18, 1875; *Rocky Mountain News Weekly*, March 17, 1875.

36. *San Juan Prospector*, July 19, 1890.

37. Ibid., August 28, 1875; *Colorado Daily Chieftain*, September 8, 1875.

38. Ellis, "Early Day Hinsdale."
39. *Colorado Springs Gazette*, March 11, 1876.
40. Nossaman, *Many More Mountains*, Vol. 1.
41. *Colorado Springs Gazette*, December 16, 1876.
42. *Golden Weekly Globe*, April 15, 1876.
43. Kindquist, *Stony Pass*.

Chapter 5

44. *Del Norte Prospector*, June 7, 1935.
45. Wattles, Wakarusa River Valley Heritage Museum.
46. Getz, "Partners in Motion."
47. Wattles, Wakarusa River Valley Heritage Museum.
48. Boyer, *John Brown*.
49. Wattles, Wakarusa River Valley Heritage Museum.
50. *Oberlin College, Early History*.
51. Twellmann and Abendroth, *Louise Otto Peters*.
52. Nanos, "'Spinster' and the Stigma of Being Single."
53. Theodore Weld Wattles, letter to sister Dr. MaryAnn Wattles Faunce, December 18, 1882.
54. *Cortez Journal*, September 30, 2011.
55. *Fort Collins Courier*, August 18, 1898.
56. *Mancos Tribune*, March 26, 1909; *Durango Democrat*, August 22, 1909; *Mancos Times-Tribune*, December 16, 1910.
57. WebMD. "Rheumatic Heart Disease."
58. *Creede Candle*, April 17, 1920; June 4, 1920.
59. Ibid., October 9, 1920.
60. Ibid., January 8, 1921.
61. Comfort, *Rainbow to Yesterday*.
62. *Creede Candle*, October 22, 1921; November 5, 1921.
63. Ibid., February 3, 1923; June 9, 1923; June 30, 1923.
64. Ibid., September 28, 1923; December 15, 1923.
65. S.C. Faunce, letter to his wife, Dr. M.W. Faunce, January 28, 1923.

CHAPTER 7

66. Nossaman, *Many More Mountains*, Vol. 2.
67. *Creede Candle*, June 30, 1893; *Silverton Standard*, March 9, 1895; *Creede Candle*, July 2, 1904; April 20, 1894.
68. *San Juan Prospector*, July 4, 1908; August 29, 1908; *Creede Candle*, May 8, 1909.

CHAPTER 8

69. *Silver World*, July 13, 1878; July 20, 1878.
70. *Silverton Standard*, Jan. 30, 1892; *Creede Candle*, September 17, 1910.
71. *Lake City Times*, April 17, 1913; *Creede Candle*, May 10, 1913; May 17, 1913; June 7, 1913; June 14, 1913.
72. *Center Post-Dispatch*, August 1, 1915.

CHAPTER 9

73. Hinshaw, *Crusaders for Wildlife*.
74. Ibid.
75. FishBase Glossary.
76. Hinshaw, *Crusaders for Wildlife*.
77. Ibid.
78. Wiltzius, *Fish Culture and Stocking in Colorado*.
79. Hinshaw, *Crusaders for Wildlife*.
80. Ibid.
81. U.S. Fish and Wildlife Service. "Tench (Tinca tinca)."
82. *Creede Candle*, January 8, 1910.

CHAPTER 10

83. Nossaman, *Many More Mountains*, Vol. 1
84. Ibid.
85. Nossaman, *Many More Mountains*, Vol. 2.
86. Ibid.

87. *Colorado Springs Gazette*, January 29, 1876.
88. Nossaman, *Many More Mountains*, Vol. 2.
89. Ibid.
90. Harriet Louise "H.L." Wason (Mrs. Martin van Buren Wason), *Ode to Grinnell*, 1887.
91. Ray Madison, *Creede Candle*, December 17, 1919.
92. Nossaman, *Many More Mountains*, Vol. 2.

Chapter 11

93. Bill, great-great-grandson of Upper Rio Grande pioneers, 1990.
94. Nossaman, *Many More Mountains*, Vol. 1.
95. Ibid., Vol. 2.
96. Ruffner, *Report of a Reconnaissance*.
97. Nossaman, *Many More Mountains*, Vol. 2.
98. Ibid.
99. *San Juan Prospector*, August 28, 1875.
100. Kindquist, *Stony Pass*.
101. *Colorado Weekly Chieftain*, July 19, 1877.
102. Nossaman, *Many More Mountains*, Vol. 2.
103. Wagner, National Historic Register Application.
104. Ibid.
105. *Colorado Weekly Chieftain*, October 10, 1878.
106. Nossaman, *Many More Mountains*, Vol. 2.
107. Ellis, "Early Day Hinsdale."
108. Ibid.
109. *Creede Candle*, May 27, 1911.
110. H.J. Miller, Monte Vista, Colorado, letter to B.H. Higgonson, Tulsa, Oklahoma, 1932.
111. Wagner, *Endangered Places of Colorado*.
112. Ibid.

Chapter 12

113. *Creede Candle*, January 7, 1892; *Aspen Weekly Times*, January 23, 1892.
114. Mumey, *Creede*.

115. *Creede Candle*, August 12, 1892; December 9, 1892.
116. Ibid., July 5, 1892.
117. Bennett, *Boomtown Boy*.
118. *Spar City Spark*, April 22, 1893; *Creede Candle*, June 1, 1894
119. Dallas, *No More than Five to a Bed*.
120. *Creede Candle*, July 15, 1905; July 25, 1908; September 1, 1906; March 30, 1907.
121. Ibid, January 30, 1904; April 28, 1906; May 8, 1909; February 5, 1910; October 22, 1910; December 24, 1910.
122. Dallas, *No More than Five to a Bed*.

CHAPTER 13

123. *Creede Candle*, March 28, 1908.
124. Mumey, *Creede*.
125. *Eagle Valley Enterprise*, June 16, 1911; *Durango Wage Earner*, June 15, 1911; *Longmont Ledger*, June 16, 1911; *Wray Rattler*, June 16, 1911; *Record Journal of Douglas*, June 16, 1911; *San Juan Prospector*, June 17, 1911; *Salida Record*, June 16, 1911; *Montrose Daily Press*, Vol. 3, no. 323, June 12, 1911.
126. *Creede Candle*, October 24, 1914.

CHAPTER 15

127. Comfort, *Rainbow to Yesterday*.
128. Letter from Quentin Roosevelt to Edith Kermit Carow Roosevelt, July 11, 1915.
129. Ibid., August 18, 1915.
130. Ibid.
131. *New York Times*, January 6, 1919.

CHAPTER 16

132. *Colorado Daily Chieftain*, June 5, 1874.

133. Nossaman, Allen. *Many More Mountains*, Vol. 2.

134. *Silverton Standard*, October 1, 1904.

135. Nossaman, *Many More Mountains*, Vol. 1.

136. Nossaman, *Many More Mountains*, Vol. 2.

137. *Colorado Weekly Chieftain*, July 10, 1879.

138. *Sierra Journal (Rosita)*, February 1, 1883.

139. *Alamosa Journal*, January 15, 1885; *Aspen Tribune*, August 31, 1895.

140. Ellis, "Early Day Hinsdale."

CHAPTER 17

141. Witter, San Juan Town Certificate of Incorporation.

142. *Colorado Transcript*, October 12, 1870; *Rocky Mountain News*, January 16, 1874; *Daily Colorado Miner*, January 31, 1874; *Colorado Daily Chieftain*, April 30, 1874.

143. *Colorado Weekly Chieftain*, April 16, 1874; *Fort Collins Standard*, June 10, 1874; *Colorado Daily Chieftain*, June 5, 1874; *San Juan Prospector*, August 22, 1874.

144. *Colorado Springs Gazette*, February 27, 1875; *Silver World*, October 16, 1875.

145. *Colorado Daily Chieftain*, September 36, 1875.

146. Nossaman, *Many More Mountains*, Vol. 2.

147. *Colorado Chieftain*, September 4, 1875. Emphasis added.

148. *Colorado Weekly Chieftain*, July 19, 1877.

149. *La Plata Miner*, December 16, 1886.

150. Ellis, "Early Day Hinsdale."

151. *Colorado Weekly Chieftain*, July 12, 1877.

152. Houston, *Cemeteries of Hinsdale County*.

153. *Aspen Weekly Chronicle*, December 23, 1889.

154. *Silver World*, January 31, 1885.

155. Bureau of Land Management. General Land Office Records.

156. *Salida Mail*, Vol. 10, No. 6, June 25, 1889; *San Juan Prospector*, June 28, 1890; October 11, 1890.

157. *Creede Candle*, June 2, 1893; July 14, 1893.

158. Bureau of Land Management. General Land Office Records.

159. *San Juan Prospector*, July 25, 1891; *Creede Candle*, October 19, 1894; September 15, 1923.

Bibliography

Bauer, William H., James L. Ozment, and John H. Willard. *Colorado Post Offices 1859–1899*. Golden: Colorado Railroad Museum, 1990.

Bennett, Lewis. *Boomtown Boy, In Old Creede, Colorado*. Chicago: Sage Books, 1966.

Benson van Horn, Beverly, ed. *Early History of Mineral and Rio Grande Counties (Living Voices of the Past)*. Tucson, AZ: Beverlys Ltd., 2000.

Boyer, Richard. *The Legend of John Brown: A Biography and a History*. New York: Random House, 1973.

Bureau of Land Management. General Land Office Records. U.S. Department of the Interior. http://www.glorecords.blm.gov.

Colorado Grizzly Project. *Does the Great Bear Still Haunt Colorado?* Boulder, CO: Earth Action Network, 1997. Gale Group. http://listsofjohn.com/ Misc/COgrizzly.txt.

Colorado Historic Newspapers Collection. www.coloradohistoricnewspapers. org/.

Comfort, Mary Appoline. *Rainbow to Yesterday*. New York: Vantage Press, 1979.

Croffut, George A. *Croffut's Grip-sack Guide to Colorado*. Vol. 2. Omaha, NE: Overland Publishing Company, 1885.

Dallas, Sandra. *No More than Five to a Bed: Colorado Hotels in the Old Days*. Norman: University of Oklahoma Press, 1967.

Ellis, Erl H. "Early Day Hinsdale County Post Offices and Managers." Personal communication with Erl H. Ellis, February 14, 1975.

FishBase Glossary. Accessed October 30, 2016. http://www.fishbase.org/ glossary/Glossary.php?q=eyed+eggs.

Gambone, Joseph G., ed. *The Forgotten Feminist of Kansas: The Papers of Clarina I.H. Nichols, 1854–1885.* Vol. 39, no. 3, 392–444. Kansas State Historical Society, 1973.

The GeoZone. *The Lost Mine on Bear Creek.* Accessed May 28, 2016. http://www.thegeozone.com/treasure/colorado/tales/co010a.jsp. Geology Park LLC 2000–15.

Getz, Lynne Marie. "Partners in Motion: Gender, Migration, and Reform in Antebellum Ohio and Kansas." *Frontiers: A Journal of Women Studies* 27, no. 2 (2006): 102–35.

Gilmour, Frances, and Louisa Wade Wetherill. *Traders to the Navajos: The Story of the Wetherills of Kayenta.* Albuquerque: University of New Mexico Press, 1953. Reprint, Kessinger Publishing, LLC, 2007.

Gilpin, Laura. *The Rio Grande—River of Destiny.* New York: Duell, Sloan and Pearce, 1949.

Gordon, Ann D., ed. *The Selected Papers of Elizabeth Cady Stanton and Susan B. Anthony: In the School of Anti-Slavery, 1840 to 1866.* New Brunswick, NJ: Rutgers University Press, 1997.

Hafen, LeRoy R., and Ann W. Hafen, eds. *The Diaries of William Henry Jackson, Frontier Photographer: With the Hayden Surveys to the Central Rockies, 1873, and to the Utes and Cliff Dwellings, 1874.* Glendale, CA: A.H. Clark Company, 1959.

HeritageQuest Online. http://www.ancestryheritagequest.com/.

Herodotus. *The Persian Wars,* 8.98.

Hinsdale County Records, Lake City, Colorado. Recorded documents: Land, Marriage, Birth.

Hinshaw, Glen A. *Crusaders for Wildlife.* Lake City, CO: Western Reflections Publishing Company, 2000.

Houston, Grant E. *Cemeteries of Hinsdale County, Colorado, 1874–1995.* 2nd ed. The Society, 1989. Revised 1996.

Kindquist, Cathy. *Stony Pass: The Tumbling and Impetuous Trail.* Silverton, CO: San Juan County Book Company, 1987.

LaFont, John. *58 Years around Creede.* Alamosa, CO: Sangre de Cristo Printing, 1971.

———. *The Homesteaders of the Upper Rio Grande.* Birmingham, AL: Oxmoor Press, 1971.

Leggett, Mike. *Rio Grande.* Longstreet Press, 1994.

McNitt, Frank. *The Indian Traders.* Albuquerque: University of New Mexico Press, 1989.

———. *Richard Wetherill—Anasazi.* Rev. ed. Albuquerque: University of New Mexico Press, 1974.

Merriam-Webster. Accessed October 23, 2016. www.merriam-webster.com/.

Mineral County Records. Creede, Colorado.

Mumey, Nolie. *Creede: History of a Colorado Silver Mining Town*. Denver, CO, 1949.

Nanos, Janelle. "'Spinster' and the Stigma of Being Single." *Boston Daily*, January 10, 2012. http://www.bostonmagazine.com/news/blog/2012/01/10/spinster-and-the-stigma-of-being-single/.

Nossaman, Allen. *Many More Mountains*. Vol. 1, *Silverton's Roots*. Denver: Sundance Books, 1989.

———. *Many More Mountains*. Vol. 2, *Ruts into Silverton*. Denver: Sundance Books, 1993.

Oberlin, Early History. Accessed December 8, 2016. https://new.oberlin.edu/about/history.dot.

Ruffner, Lieutenant E.H. *Report of a Reconnaissance of the Ute Country Made in the Year 1873*. Washington, DC: Government Printing Office, 1874.

Sagamore Hill National Historic Site. Letter from Quentin Roosevelt to Edith Kermit Carow Roosevelt, August 18, 1915. Theodore Roosevelt Digital Library. Dickinson State University. http://www.theodorerooseveltcenter.org/en/Research/Digital-Library/Record.aspx?libID=o276089.

———. Letter from Quentin Roosevelt to Edith Kermit Carow Roosevelt, July 11, 1915. Theodore Roosevelt Digital Library. Dickinson State University. http://www.theodorerooseveltcenter.org/en/Research/Digital-Library/Record.aspx?libID=o276053.

Sarah Platt Decker Chapter of the D.A.R. *Pioneers of the San Juan County*. Colorado Springs, CO: Out West Printing, 1942.

Schmelling, Joseph. *Cowboy and Indian Traders*. Albuquerque: University of New Mexico Press, 1974.

Traynor, Ben. *FDR's Gold Confiscation*. The Daily Reckoning, April 10, 2013. Accessed October 23, 2016. https://dailyreckoning.com/fdrs-gold-confiscation-80-years-on/.

Twellmann, Margrit and Abendroth, Wolfgang, eds. (1972). *Louise Otto Peters. Das erste Vierteljahrhundert. S. 30. Die deutsche Frauenbewegung 1843–1889 (Marburger Abhandlungen zur Politischen Wissenschaft).* 1st ed. Berlin: Hain, 112. *Auf der Generalversammlung des Allgemeinen deutschen Frauenvereins 1873 dankt eine Referentin den Universitäten in Leipzig und Prag für die Zulassung der Frauen als Gasthörerinnen.*

U.S. Fish and Wildlife Service. *Tench (Tinca tinca) Ecological Risk Screening Summary*. Accessed May 28, 2016. https://www.fws.gov/Fisheries/ANS/erss/uncertainrisk/Tinca-tinca-WEB-09-05-2014.pdf. 09/05/2014.

U.S. Forest Service historical file folder 2210. Del Norte, Colorado office.

Wagner, Sandra. *Endangered Places of Colorado: Lost Trail Station*. Submitted to Colorado Preservation, Inc., 2009.

———. National Historic Register Application for Lost Trail Station. Submitted to the Office of Archaeology and Historic Preservation for the state of Colorado, 2011.

Wattles. Augustus Wattles. Wakarusa River Valley Heritage Museum. Accessed October 23, 2016. http://www.wakarusamuseum.org/images/PDFs/Augustus%20Wattles.pdf.

WebMD. Rheumatic Heart Disease. Accessed October 26, 2016. http://emedicine.medscape.com/article/1962779-overview.

Wetherill Family. www.wetherillfamily.com/. Copyright ©1999–2016 Wetherill Family.

Wetherill, Hilda Faunce. *Desert Wife*. Lincoln, NE: Bison Books, 1981. First published 1938 by Little, Brown and Company.

Wiltzius, William J. *Fish Culture and Stocking in Colorado, 1872–1978*. Denver: Colorado Division of Wildlife, 1985.

Witter, Daniel. San Juan Town Certificate of Incorporation, December 6, 1873. Filed with the Territory of Colorado, December 8, 1873. Colorado Archives, Denver, Colorado.

Witter, Mrs. Daniel. "Pioneer Life." *Colorado* 4, no. 5 (December 1927). Denver: The State Historical and Natural History Society of Colorado.

Wolle, Muriel Sibell. *Stampede to Timberline*. Self-published 1949. Reprint, Chicago: Sage Books/Swallow Press, 1971.

Wood, Frances and Wood, Dorothy. *I Hauled These Mountains in Here*. Caldwell, ID: Caxton Printers Limited, 1977.

Newspapers

Alamosa Journal
Aspen Weekly Chronicle
Aspen Weekly Times
Center Post-Dispatch
Colorado Daily Chieftain
Colorado Springs Gazette
Colorado Transcript
Colorado Weekly Chieftan
Cortez Journal

BIBLIOGRAPHY

Creede Candle
Daily Colorado Miner
Del Norte Prospector
Denver Daily Times
Durango Democrat
Fort Collins Courier
Fort Collins Standard
Golden Weekly Globe
Gold Run-Silvertip
Lake City Times
La Plata Miner
Mancos Times
Mancos Tribune
New York Times
Rocky Mountain News
Rocky Mountain News Weekly
Salida Mail
San Juan Prospector
Sierra Journal (Rosita)
Silverton Standard
SilverWorld
Spar City Spark

INDEX

About the Authors

My husband's family has deep roots in the United States, going back to the *Mayflower*. Those roots have been planted in Colorado since the mid-1800s and in the Upper Rio Grande since the late 1890s. It has been fun to see the family stories my mother-in-law is famous for telling unfold on the computer screen.

I grew up in northern Colorado, attended college, served two years in the Peace Corps in Ghana, West Africa, and worked for many years as a chemist at Los Alamos National Laboratory in New Mexico. I retired in 2008, moved to Colorado and now teach chemistry part-time at Adams State University. I enjoy training mules and rescuing dachshunds, writing history and living at Lost Trail Station on the Upper Rio Grande. My years of working allowed me to accumulate many writing and computer skills, which have been well utilized in the preparation of this book.

Carol Ann grew up as a fourth-generation native in the Upper Rio Grande and collected many local and family stories in her eighty-four years. Some say her collection of old newspaper clippings, photographs, letters and miscellaneous pieces of paper are just piles of trash—but what a treasure trove of information we have gleaned from them. The "boxes," as they are affectionately known, occupy all of the space in her sitting room and spill over into the kitchen and the living room. The sorting (and re-sorting) of the contents has been assigned to our beloved Bill, my husband and her son. This has truly been a family project.

In addition to the history on hand, Carol Ann also spent many hours on the Colorado Historic Newspapers Collection and Heritage Quest websites,

Authors Sandra Wagner and Carol Ann Wetherill driving Sweetie Pie, 2016. *Author collection.*

teasing out tidbits of supporting information for the stories. Also, with photos and information from local historical societies, books, articles and various Internet sites, we collect the pieces and parts and write something up that is critically reviewed and edited—what a team.

We started writing our joint history articles back in 2006, and we wrote one every year for the Lake City, Colorado newspaper. We recently realized that we had quite a collection of stories and thought they would make an interesting book. We hope you agree. It's been fun, and we can't wait to complete the next one!

Sandra Wagner and Carol Ann Wetherill